I'VE BEEN SHOOTING IN THE [...] G
by
John Hume

A Photographic record of 12 years of Bob Dylan in Concert
(1984 - 1995)

My thanks to the following people for helping in various ways on the many tours. Some provided front row seats, and drove for thousands of miles on our trips through the USA and Europe, while others booked flights, hotels, trains, boats etc. etc. Others invited me into their homes sometimes without even having met before.

To all these, I give my appreciation for your help and friendship:-

Pete and Barbara Morris, Hans and Lucie Van Gils, Bas Aarts, Brian McRoberts, Steiner Daler, Michael Krogsgaard, Magne Karlstad, John Bauldie, Dave Dingle, Paul Williams, Mauro de Marco, Hubert and Helga Mörtl, Rick Kucemba, Lawrence Kirsch, Dan Mahoney, Glen and Madge Dundas, Wesley Walker and Yvonne Maxwell, Jeff Friedman, Vicki Jackson, Adrian Richardson, Andrea and Graziella Orlandi, Claudio Panontin, Willem Meuleman, Christian Behrens, Andrew Muir, Gillian McLaughlin, Helle Skytte and Henning Bojensen, Joe and Hazel McShane.

And for extraordinary help, above and beyond the call of duty, a very special thanks to Bill Sommariva, Keith Stauring and Steve Keene.

. . . and Thanks, of course, to Bob Dylan.

First published February 1996

All photographs © John Hume

Bulletproof Books
6 Oaklands, Cradley,
Malvern,
Worcestershire.
England. WR13 5LA ISBN 0 9527451 0 0

In memory of my brother
George Morrison Hume

I'VE BEEN SHOOTING IN THE DARK TOO LONG

FOREWORD
by Paul Williams

What difference does it make what Bob Dylan looks like? I could say that, but I'd be kidding myself, and you. Sure, music is experienced through the ears, but the supplementary visual element has always - with Elvis, Dylan, the Stones, the Beatles, even Hendrix - been an important factor, enabling the listener to fall in love or identify or otherwise project, and complete this sense of being connected.

When I'm at a Dylan concert for the first time in months or more, there's always that moment, sitting in my seat or standing near the front of the stage (notice how I want to get as *close as possible*, and not because the sound is better in the front row! Hmm....), that moment when the astonishing thought passes through my mind that soon, in a few minutes, I'm going to see *Bob Dylan* standing right here in front of me! How fortunate for the true fan or art - appreciator to be alive in the same century and moment as the artist, and therefore to have the opportunity to experience his or her work in person, in the artist's presence.

For me, this marvellous scrapbook of John Hume's is the missing link that makes my collection of audio tapes and memories of Bob Dylan in concert over the last twelve years complete in just the funny way that his albums wouldn't feel complete to me if they were just pieces of plastic without the album covers and their images of the artist, my imaginary pal, my hero.

What difference does it make what Bob Dylan looks like? Offer me a seat outside the theatre where I can hear tonight's concert live on the radio with impeccable soundboard sound and you (and I) will soon find out that *seeing* him is mysteriously important to me. Even a TV broadcast wouldn't tempt me, no matter how much you offered me for my theatre ticket. I like videos okay, but I'd rather be at the show, of course, but if I can't be there the audio tapes actually work better for me, in terms of the potential of having a great aesthetic experience, than the videos. So it's not just about *seeing* what he looks like. (Though I do get a great kick out of the humour and all the other feelings he expresses with his face and his body movements as he performs.) It's about being present with the singer and the music he and his band are creating. And for me, these concert photos by John Hume, not a professional photographer but a fellow fan like myself who truly knows and understands the fan's excitement at being *here,* in the Supper Club or Slane Castle this particular evening... these concert photos are the missing album covers that my live Dylan tapes never had. Try looking at a photo as you listen to the concert it's from! Imagination is a vital part of the creative process, and I do believe we listeners and readers and observers do play an important part in creating (or completing the creation of) the music and books and paintings we give our attention to.

Thanks, John, for being at the shows! And for making your souvenir book available to us fellow-appreciators....

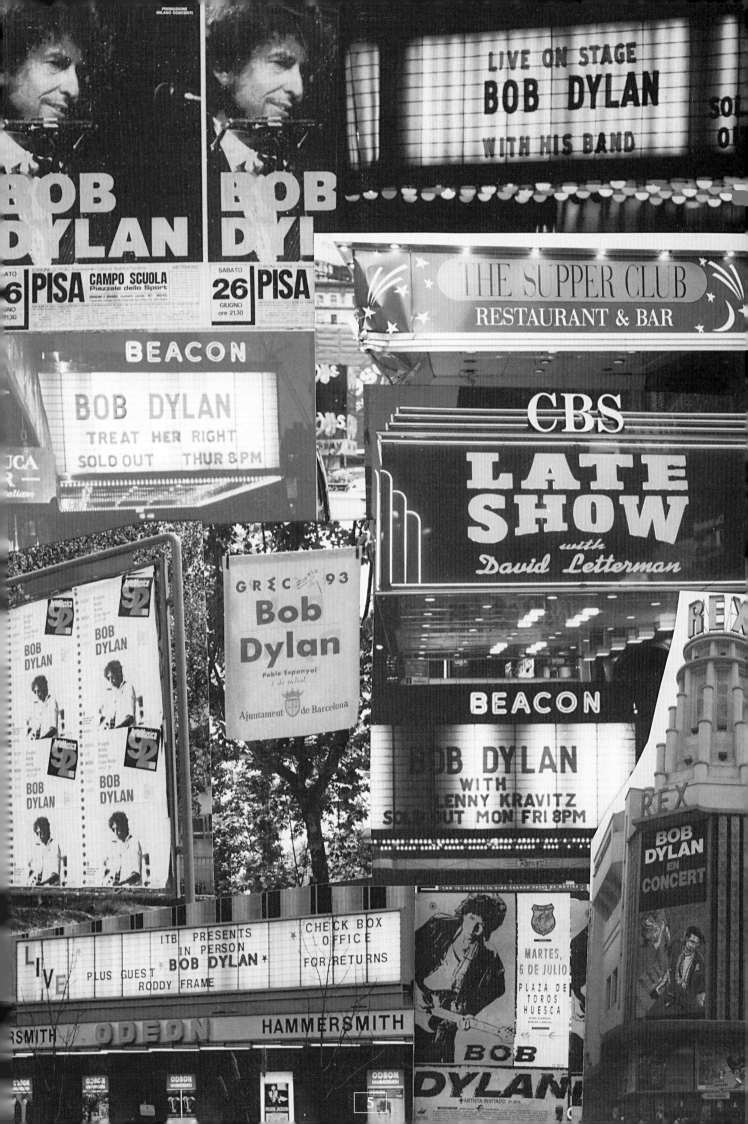

INTRODUCTION

It's getting dark, too dark to see.

From Belfast to Budapest, from Paris to Poughkeepsie, from Warsaw to Washington, I've been fortunate enough to see Bob Dylan in concert on over 150 occasions between 1978 and 1995.

I didn't even own a camera when I went to my first Dylan concerts in England in 1978 and 1981, and even though some photos were appearing in the fanzines during those periods, when I wrote and asked the people who had taken them could I buy copies for myself, nobody would sell them. On most occasions they wouldn't even reply to the letters. I soon realised that if I wanted any souvenir 'snaps' from any future shows, the only way I could get them was to take the pictures myself!

So in late 1981, with some advice from a photographer friend, I bought my first camera, naïvely assuming that having played shows in '78, '79, '80, and '81, Dylan would be around sometime in 1982 and I should at least try and be prepared for when I got a chance to take my first photos of him. Foolish me! With hindsight, this would turn out to be the predictable period of Dylan only setting foot in the U.K. and Europe every 3 years, ('78, '81, '84, '87) so I had quite a wait until I saw him again in Europe in 1984.

Then the 'fun' would really begin, trying to smuggle cameras and lenses and film into the concert each night. There would be the body searches when entering the venue. In some venues the security would even be mingling with the crowds on the floor and searching people during the show. On other occasions they would wait until the concert had finished and then approach you, demanding that you hand over your film.

The restrictions printed on the back of the tickets would vary from country to country, and would rapidly grow from the usual 'no bottles, cans, tape recorders' etc. to include such things as fireworks, lasers, lawn furniture!, and other such items that you never leave home without when setting off for a concert. But my favourite has to be the

sign outside the Saratoga Performing Arts Centre in upstate New York, (this is an official plaque on the wall applying to all events at the venue) which included in the list of items that would be confiscated at the door, ' no marshmallows' ! Now that's what I call tight security!

Before Dylan would take to the stage they would make the announcement:

"We would like to remind you that the use of cameras and recording devices of any kind is not permitted during this evening's performance. This policy will be strictly enforced - we appreciate your co-operation. Thank you, and enjoy the show."

Usually the end of the message was drowned out by the jeering and booing from the audience.

Dylan has never been comfortable around cameras, on stage or off, whether in his scuffles with photographers outside hotels, at airports and other public places, or shouting "No photos!" in the middle of a concert to a member of the audience.

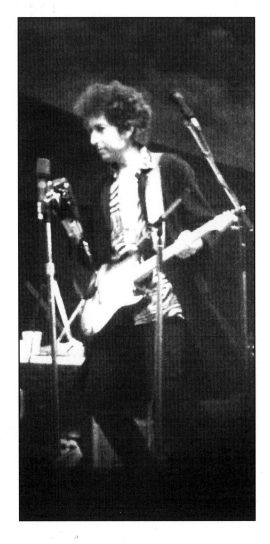

Although on one occasion he did have a more light-hearted approach. During a large open air concert at Slane in Southern Ireland in 1984 he noticed someone near the front of the crowd taking photo after photo after photo. Dylan went to the rear of the stage and picked up a camera belonging to a journalist working on stage throughout the show.

Dylan then ran back to the front of the stage with the camera, bent down, and proceeded to take photos of the person in the audience, as if to say "See how you like it!"

Slane Castle 8th July 1984
Dylan returns the journalist's camera after having photographed a member of the audience.

In many interviews over the years he has voiced his dislike of having his photo taken. Here are just a couple of examples:-

Replying to Edna Gunderson in a 1990 interview (printed in USA Today - 14th Sept.1990) Dylan said:

> "It rubs me the wrong way, a camera. It doesn't matter who it is, somone in my own family could be pointing a camera around. It's a frightening feeling. Cameras make ghosts of people."

And the following is an extract from an interview with Randy Anderson in 1978 (printed in The Minnesota Daily - 17th Feb. 1978):

Anderson: ...an interviewer sometimes feels like a thief when he interviews someone.

Dylan: Heh heh!

Anderson: It's like the old African tribesmen who feel like you're stealing part of their soul when you take a picture of them. Like I get people to talk and I get it on tape and take it home and show it to the public. That make any sense to you?

Dylan: Oh yeah. I agree with that picture taking thing. You gotta have a protective layer around ya to have your picture taken. And I feel the same exact way as those old tribesmen, about havin' your picture taken. I don't believe it's really proper, to do that to somebody else.

The New York photographer Daniel Kramer, who published a book of Dylan photos in the 1960's, was interviewed in June 1995 by Marjorie Kaufman. He talked of the difficulty in trying to take photos in such dark conditions, and referred to using shutter speeds as slow as 1 second as "that's all the light there was", and about having to adjust the camera settings by feel, in the dark.

Thirty years on, it's still extremely difficult trying to photograph Bob Dylan on stage - the lighting at a Dylan concert bears no resemblance to the stage lights of a 'normal' rock concert.

I would agree with Kramer's comments that he had to work with slower lenses and film speeds in those days, but even nowadays it's still very difficult to shoot in the dimly lit conditions, and the technological advances in cameras and films provide little or no advantage.

The stage lighting is deliberately set up to avoid Dylan's face being well lit during most of the show, usually backlighting, or a small spotlight directly above his head, causing most of his face to be in shadow.

It becomes even worse when he appears on stage wearing a hat!

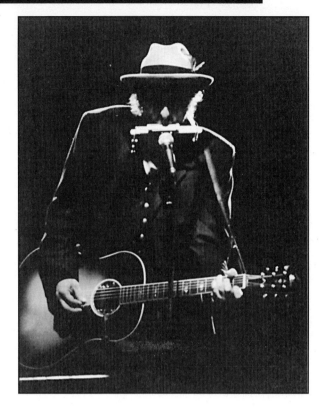

Ljubljana, Yugoslavia
10th June 1991
The difficulty in trying to photograph Dylan in poor lighting conditions.

On the rare occasions when there is any light on his face, it is usually red or ultra violet lighting - which is also a deterrent to photographers. (There is more leeway if using black and white film, but all the photos used in this book were shot on colour film.)

The only solution would be to use a flash, but the vast majority of the photos in this book were taken in the poor lighting conditions described above. I don't agree with using flash during any concert.

So this book is from a fan's perspective and not a professional photographer who had permission to take the shots. I had no special privileges, no photographer's pass, the photos in this book were all taken without permission. I was subjected to the same body searches as everyone else when entering the building. I would be in the crowd along with the other fans, usually amidst strict security. I had to avoid all the arms waving, and people's heads getting in the way just at the wrong moment when I tried to take a photo. At the same time I had to keep one eye on the security who were waiting to pounce on anyone they noticed with a camera or tape recorder. (And they can be very intimidating when they do catch you!)

Looking back, it's been a great experience, I've met lots of interesting people and made many new friends along the way. I've visited quite a few countries I never planned to visit, although if given the chance to do it all over again I'm not sure if I would have driven hundreds of miles through Yugoslavia to see Dylan in Belgrade two weeks before the war broke out. And would I have got up in the middle of the night to catch a 5am train across Poland, only to have the show cancelled after 7 or 8 songs because of a severe thunderstorm?

It was difficult choosing which photos would finally be included in the book. Everyone who was asked to pick out some, chose completely different shots, so that wasn't really helpful. Ignoring everyone's contradictory advice, the final choice was mine.

So I hope you enjoy these photos, and that they bring back memories of particular shows for you, or your favourite period of seeing Dylan. Hopefully, anytime you pick up the book and glance through it, it will be a nice reminder of those times.

John Hume

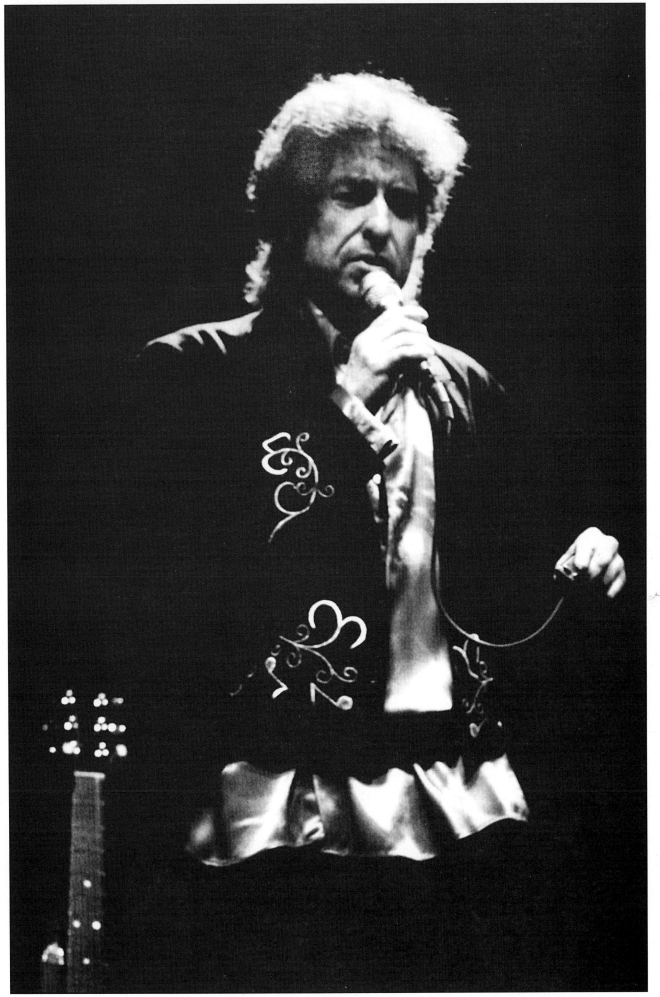

Birmingham 2nd April 1995

Concert le 3/07

RTL avec

N⁰ 0252

Bill Graham & David Zard presentano

BOB DYLAN SANTANA

POSTO UNICO

ALBERT KOSKI présente

DYLAN SANTANA

GRENOBLE ALPEXPO
LUNDI 2 JUILLET 84 - 21 h.
Ouverture des portes : 18h.

100 F

...its de location en sus.
...T.V.A. incluse.

020799

ARENA DI VERONA
Lunedì 28 Maggio 1984 - Ore 20
(Apertura cancelli Ore 18,30)

...jensen & DKB in association with Bill Graham
proudly present

DYLAN SANTANA

1984

RETEQUATTRO

Plus special guests

ULLEVI lördagen 9 juni kl. 15.00

Publikinsläpp från ...

WEMBLEY STADIUM

Mel Bush and Harvey Goldsmith
in association with
Bill Graham
present

BOB DYLAN E...

upptagning förbjudet
flaskor och burkar

en

Nr 6018

TURNSTIL...

BOB DYLAN/SANTANA

Maandagavond, 4 juni 1984 20.00 uu
Ahoy' Sportpaleis Rotterdam

BEWIJS VAN TOEGANG **f 45.—**

geluids-opnameap...
en op straffe van...

STAANPLAATS
4 juni 1984

ARENA 001149

...en de poorten van...

Harvey Goldsmi... ...ush by arrangement with
Bill Graham proudly present

BOB DYLAN SANTANA
in concert

THURSDAY 5TH JULY 1984

£11 inc VAT in advance
£12 inc VAT on the day

TO BE RETAINED

NEWCASTLE UNITE...
St. James Park

Do not bring bottles or cans. Ticket holders conser...
the filming and sound recording of themselves ...

ZERO PRODUCTIONS PRESENTE
BY ARRANGEMENT WITH A.K. & B.G.
"UN CONCERT DANS LE PARC"
AVEC

avec RTL

BOB DYLAN SANTANA
SPECIAL GUEST
JOAN BAEZ

...N ACCORD AVEC LE CONSEIL GENERAL DES HAUTS DE SEINE

110F. N⁰ **06694**

PARIS / PARC DE SCEAUX
DIMANCHE 1ᵉʳ JUILLET 1984

WIENER ST...

STEHPL.PAR...

...00 LINKS

...stalter WIENER STADTHA...

DYLAN-SANTANA

...NNERSTAG
84.06.14

'TV3
TELEVISIÓ DE CATALUNYA

CATALUNYA RADIO
PRESENTAN

En discos CBS

N⁰ 03626

La adquisición
de esta entrada significa...

BOB DYLAN
+Artista Invitado

JUEVES 28 DE JUNIO
A LAS 22.00 H.
EN EL MINI ESTADI...

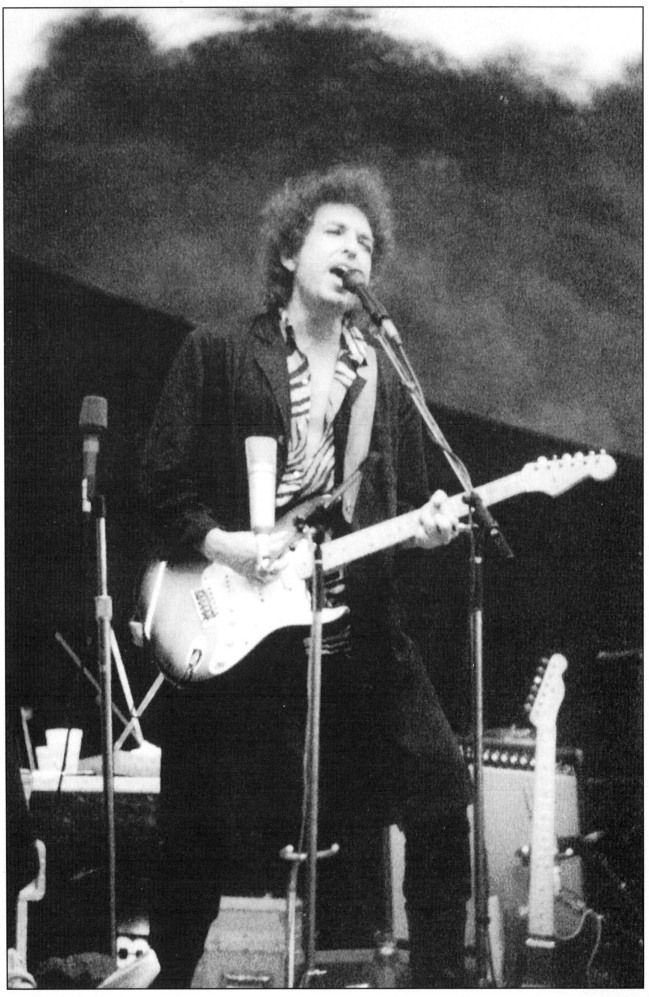

Slane Castle 8th July 1984

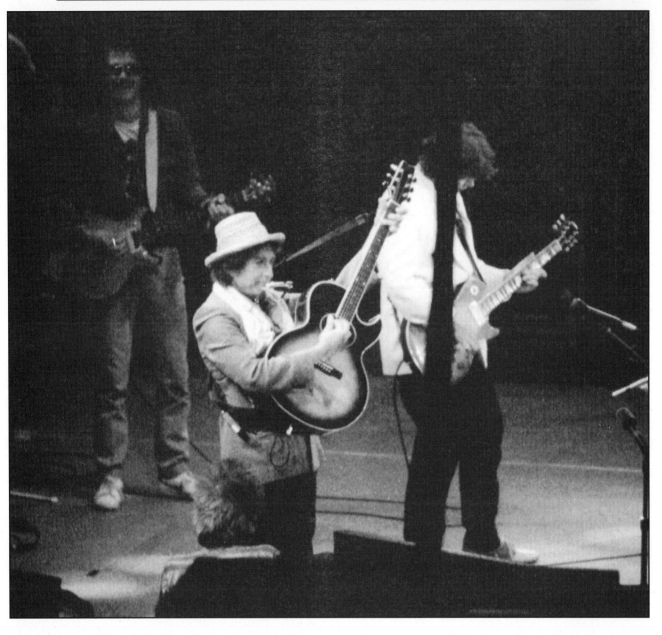

Carlos Santana Mick Taylor

Bob Dylan

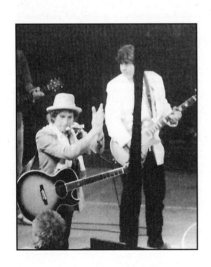

Rotterdam 6th June 1984

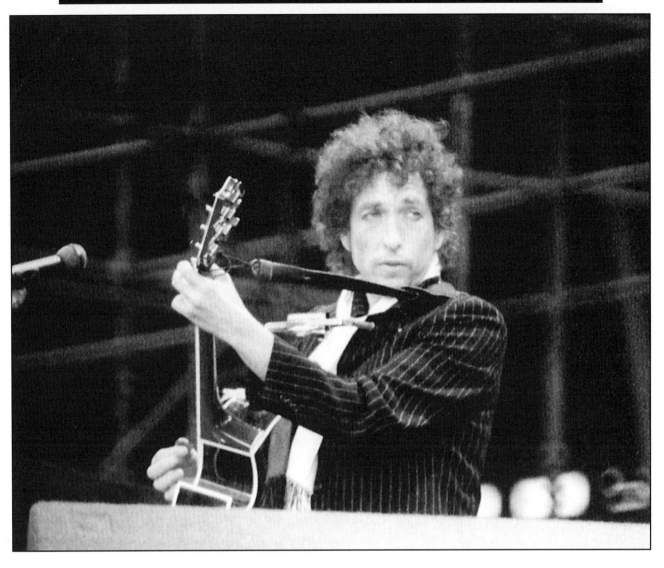

Copenhagen 10th June 1984

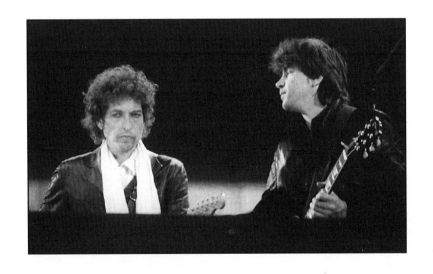

Gothenburg 9th June 1984

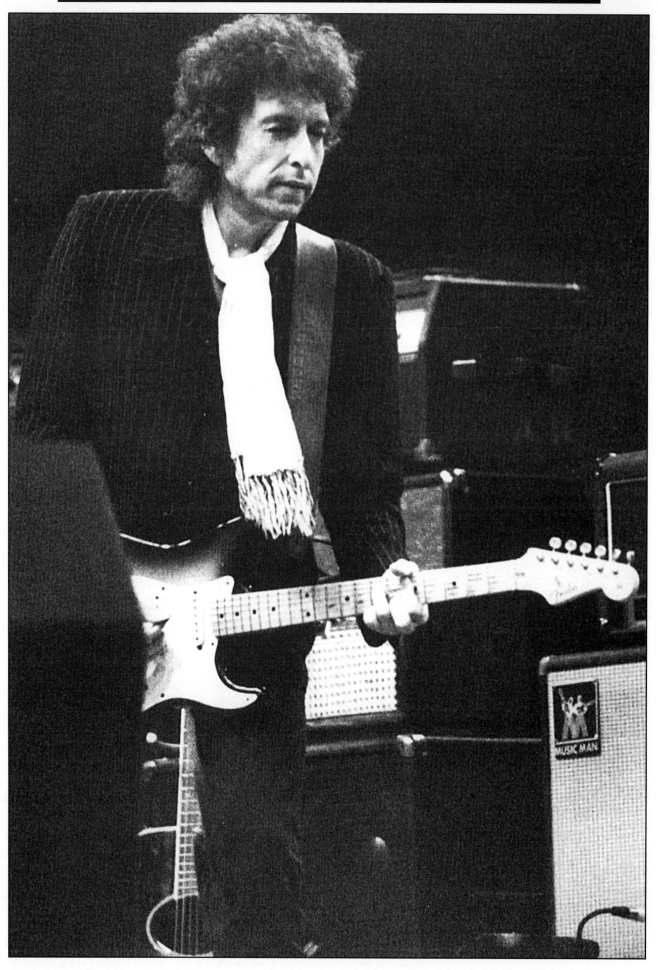

Cologne 16th June 1984

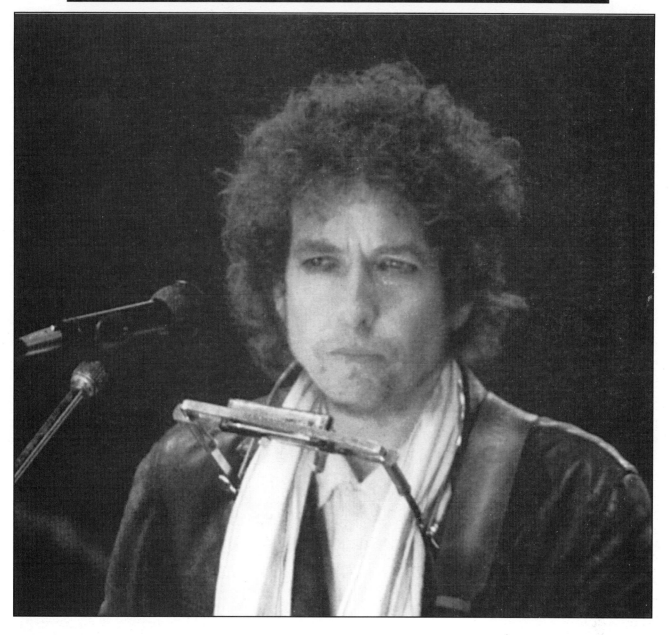

Gothenburg 9th June 1984

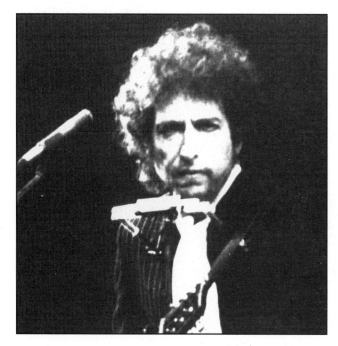

Cologne 16th June 1984

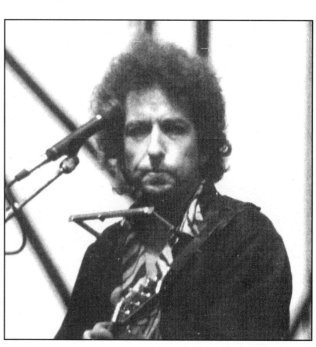

Newcastle 5th July 1984

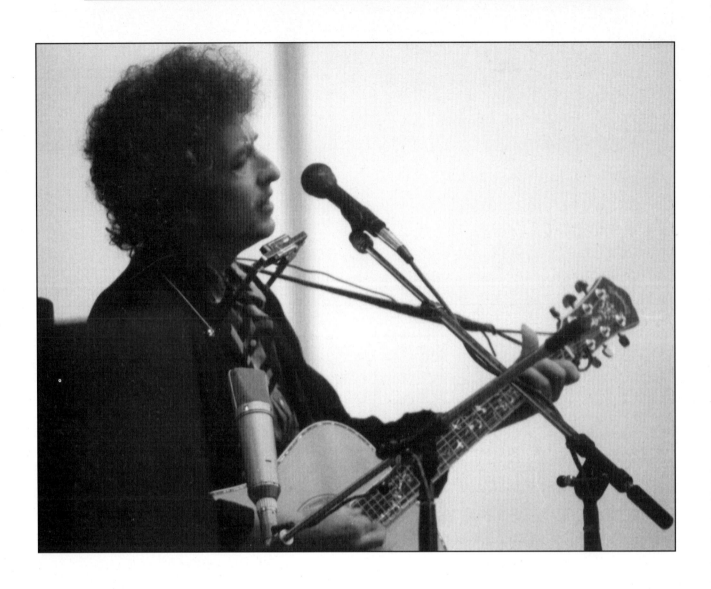

Slane Castle Nr. Dublin 8th July 1984

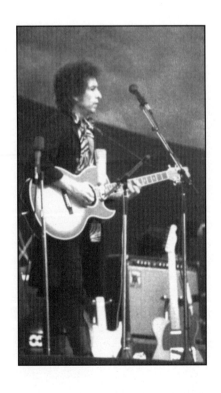
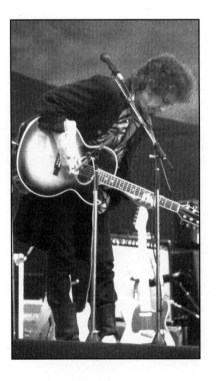
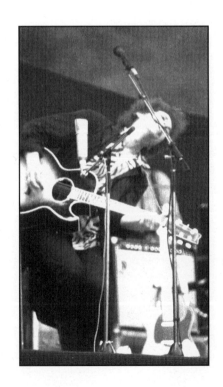

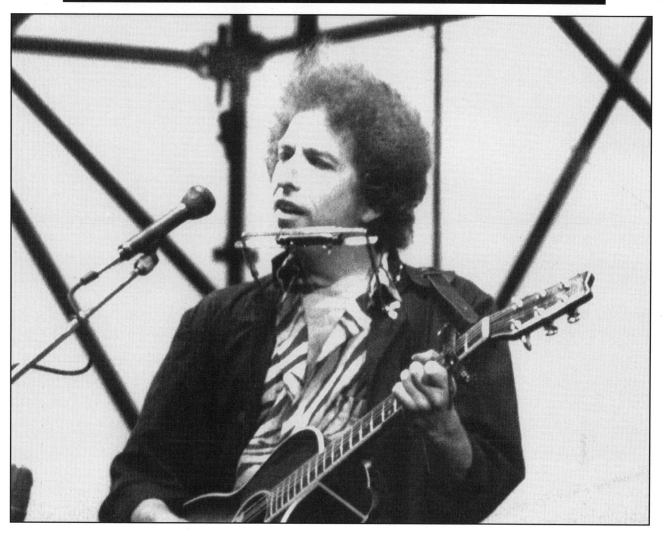

Newcastle 5th July 1984

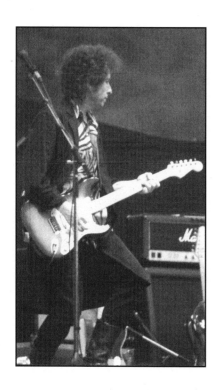 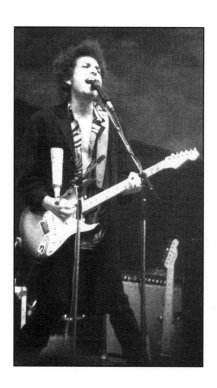 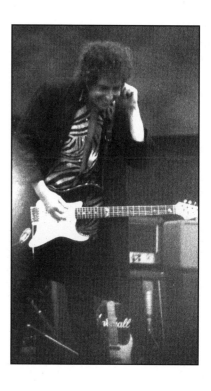

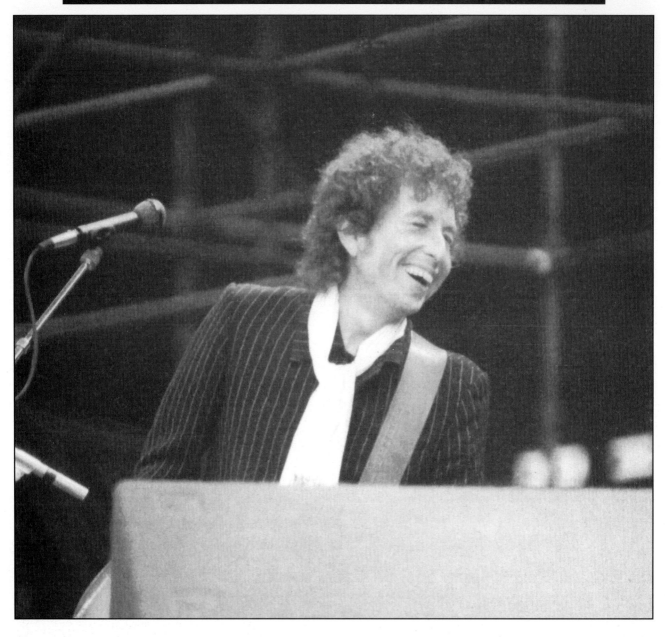

Copenhagen 10th June 1984

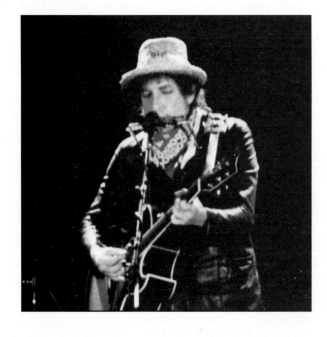

Brussels 7th June 1984

No - I've no idea what it means!
(The Belgians are a strange crowd)

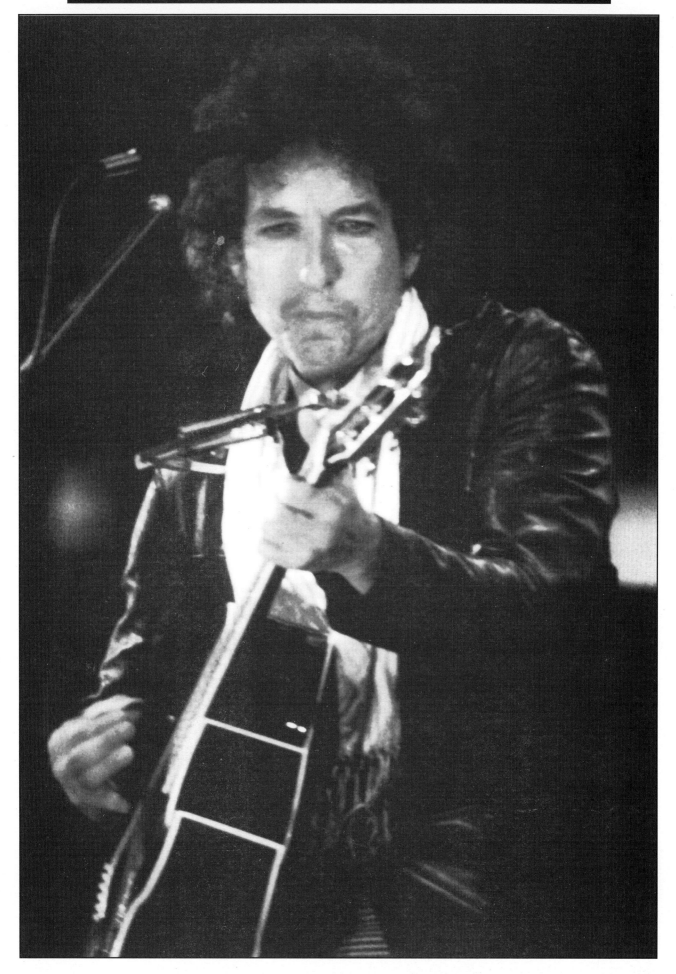

Gothenburg 9th June 1984

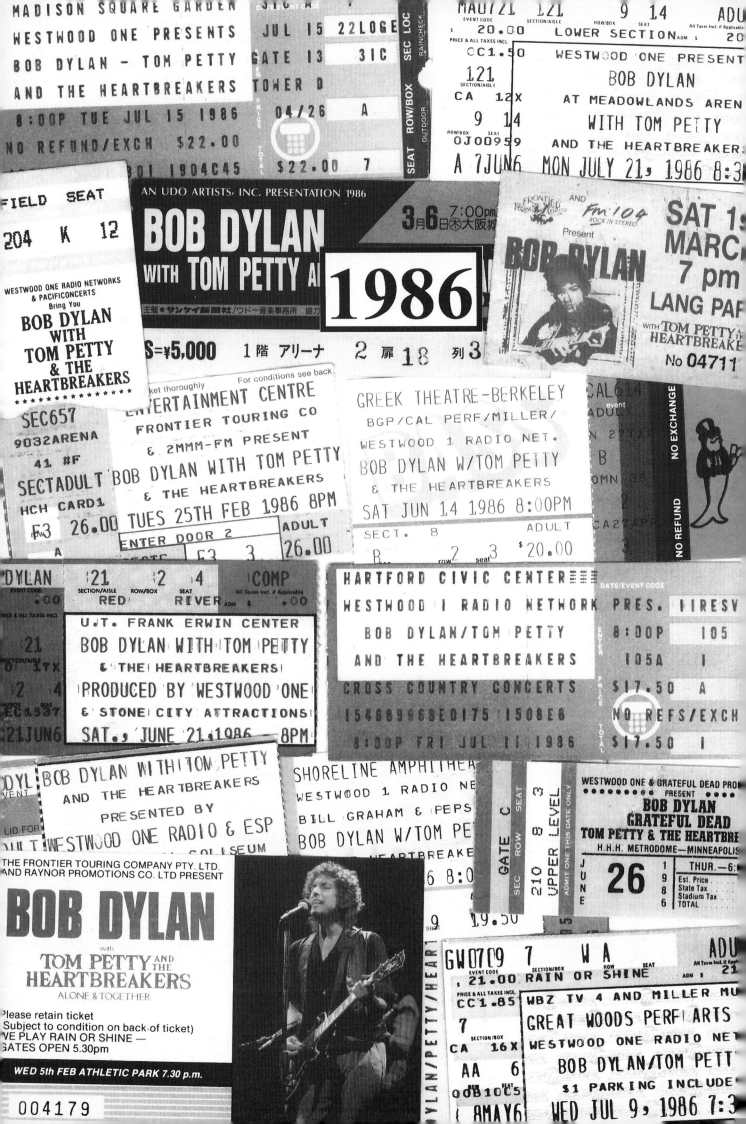

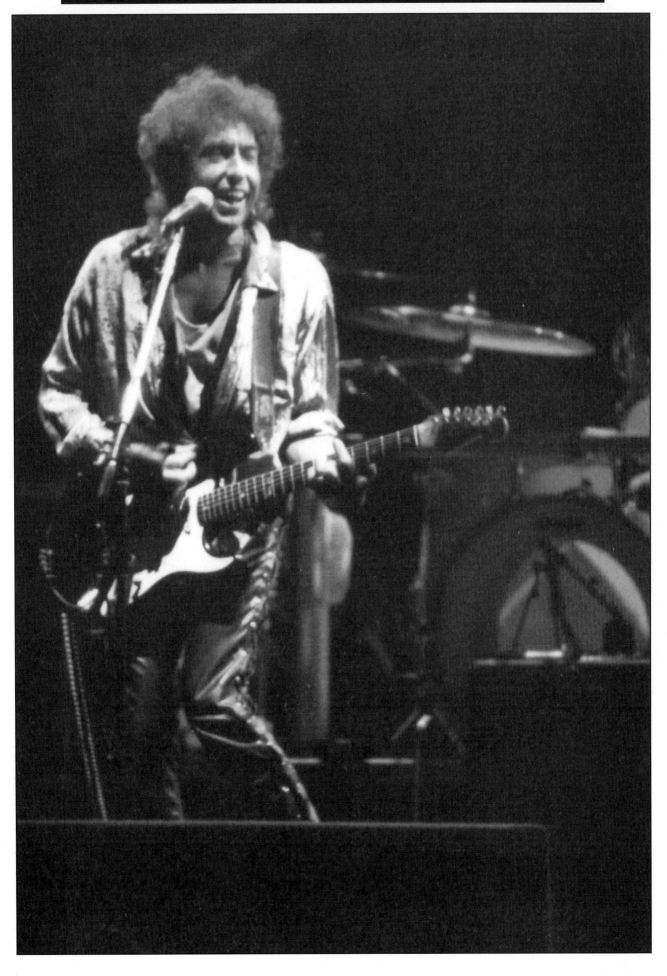

I'VE BEEN SHOOTING IN THE DARK TOO LONG

Philadelphia 19th July 1986

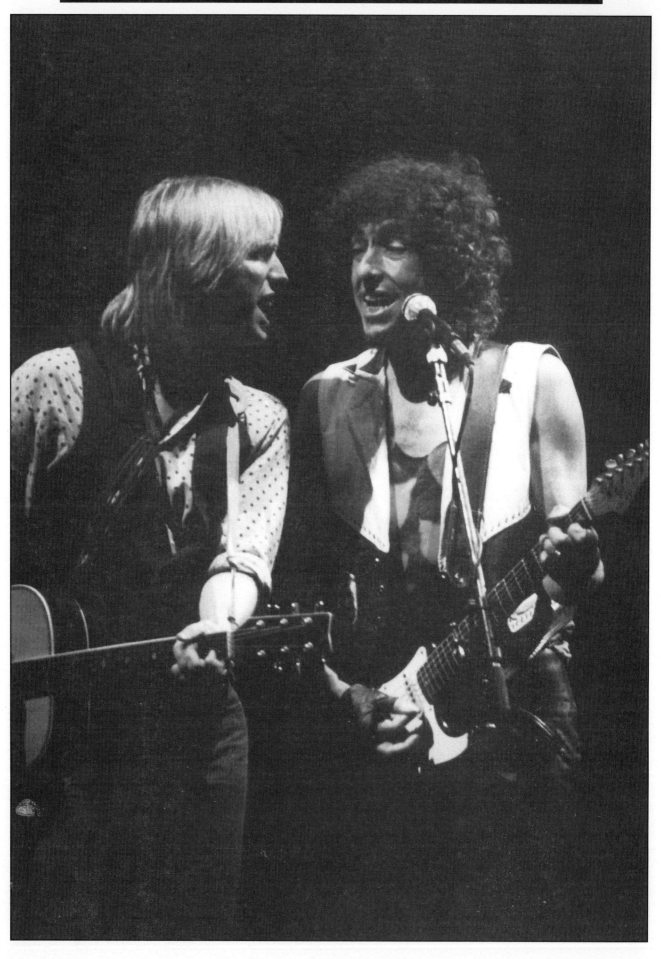

Philadelphia 20th July 1986

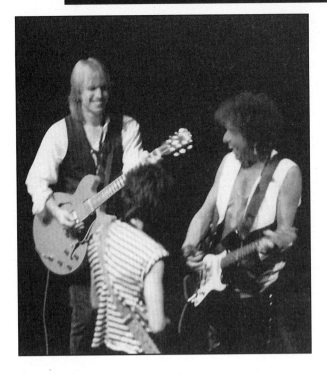

Tom Petty Bob Dylan Bob Dylan Ron Wood
 Ron Wood Howie Epstein Tom Petty

Madison Square Garden New York
15th, 16th, 17th July 1986

 Ron Wood Tom Petty Mike Campbell
Benmont Tench Bob Dylan

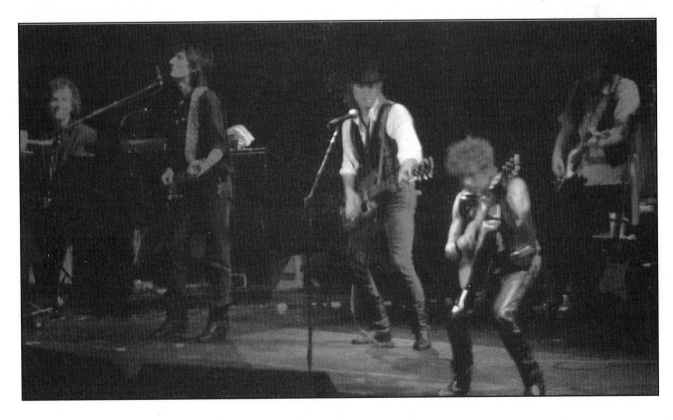

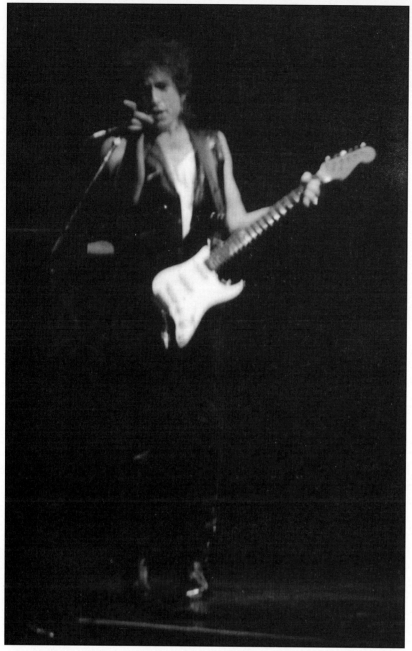

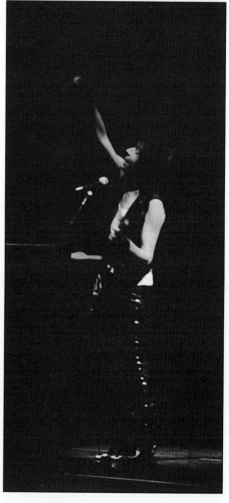

Meadowlands New Jersey
21st July 1986

Madison Sq. Garden New York
15th July 1986 26

New Jersey
21st July 1986

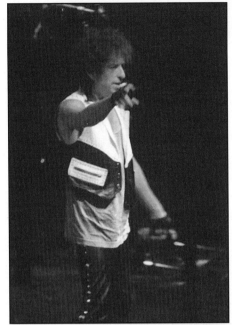

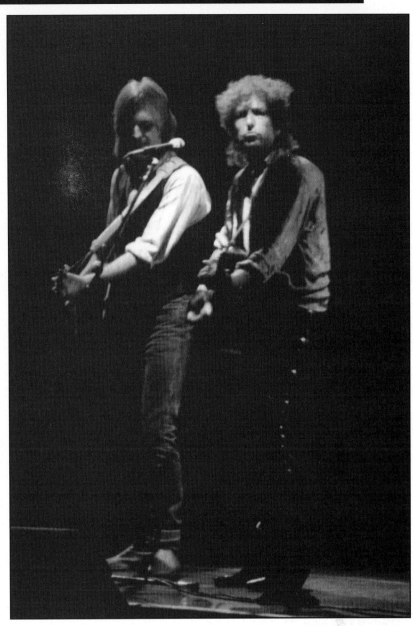

New Jersey 21st July 1986

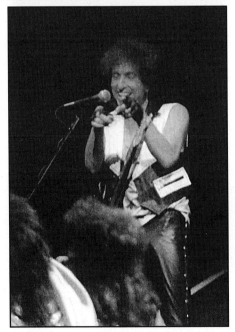

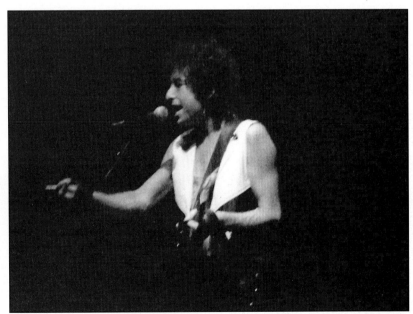

Madison Square Garden New York 15th July 1986

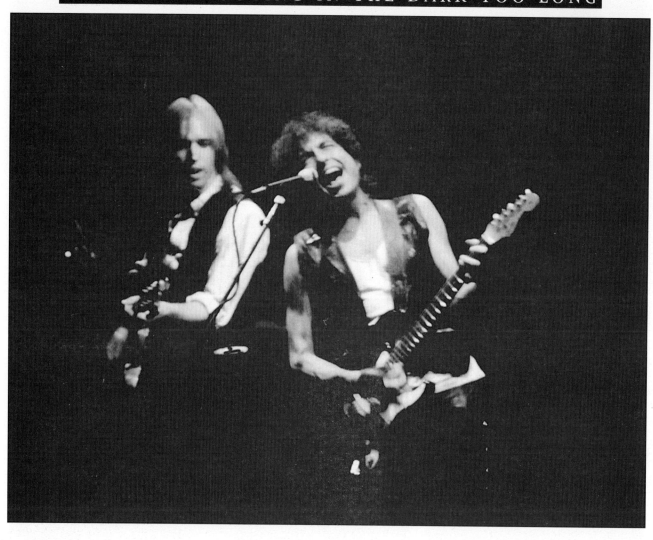

Meadowlands New Jersey 21st July 1986

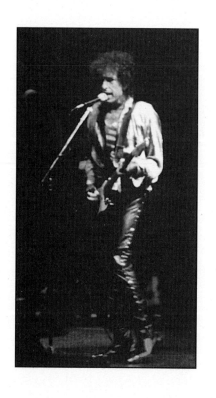
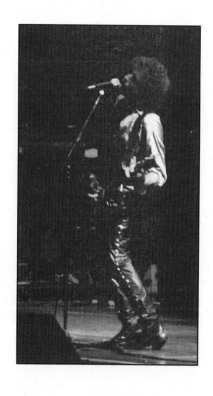
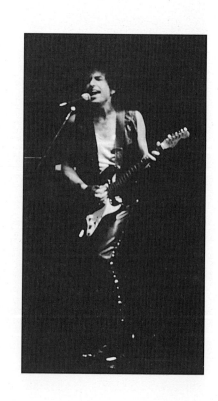

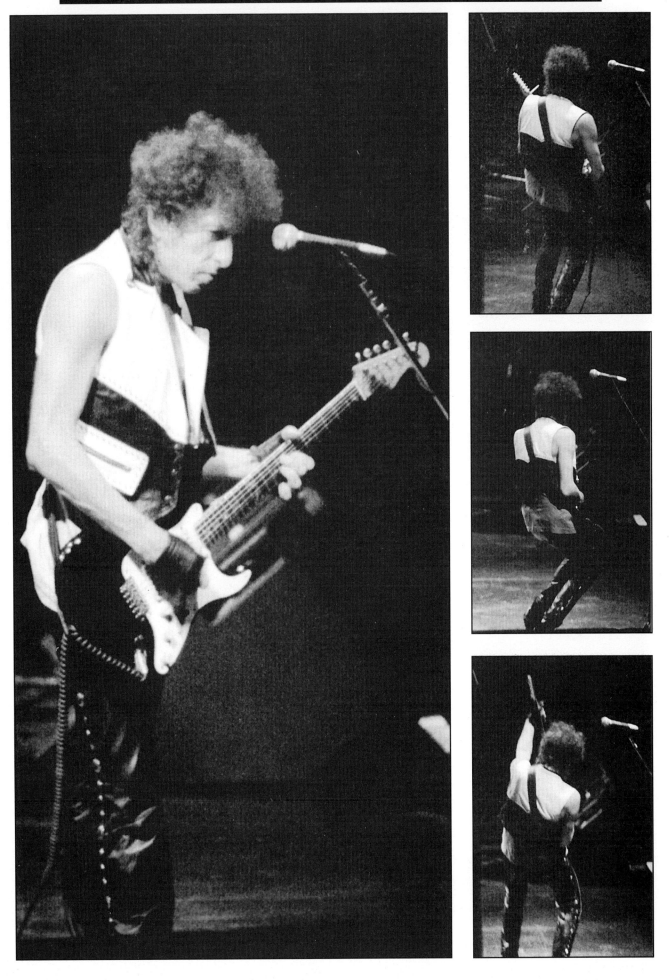

Madison Square Garden New York 17th July

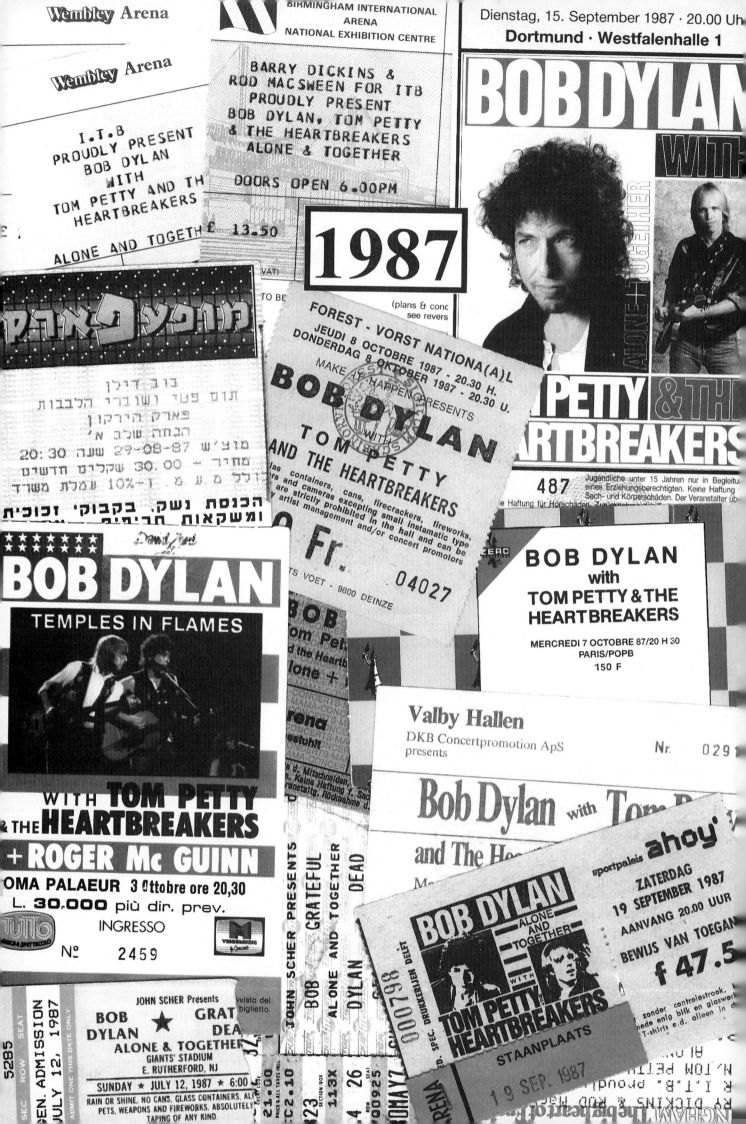

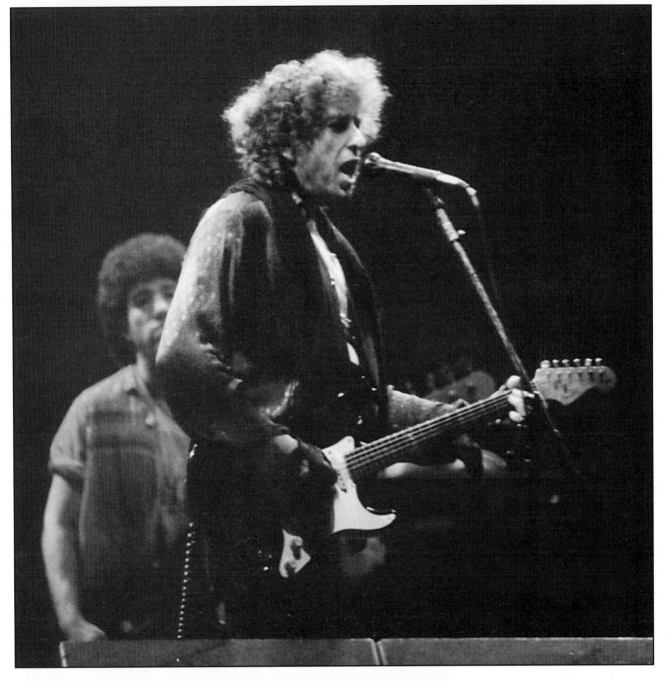

London
17th October
1987

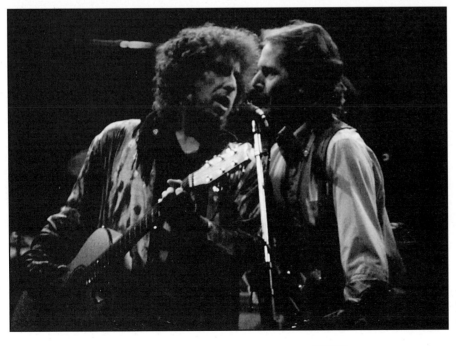

London
16th October 1987
with Roger McGuinn

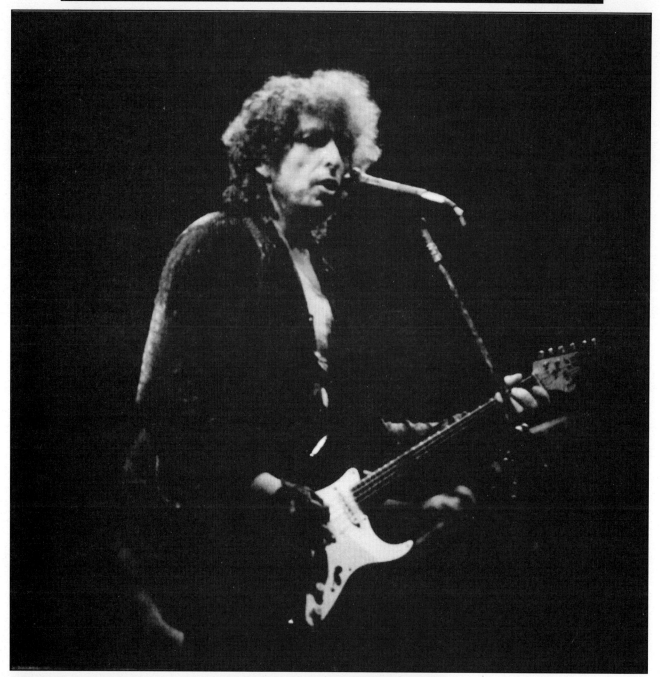

London
17th October
1987

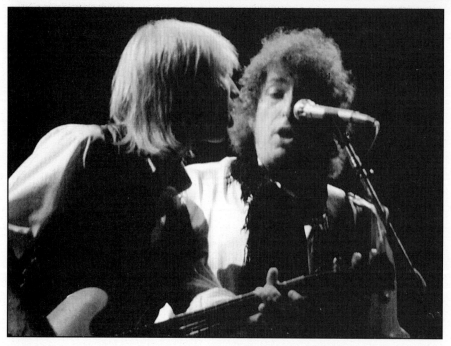

Rome
3rd October 1987
with
Tom Petty

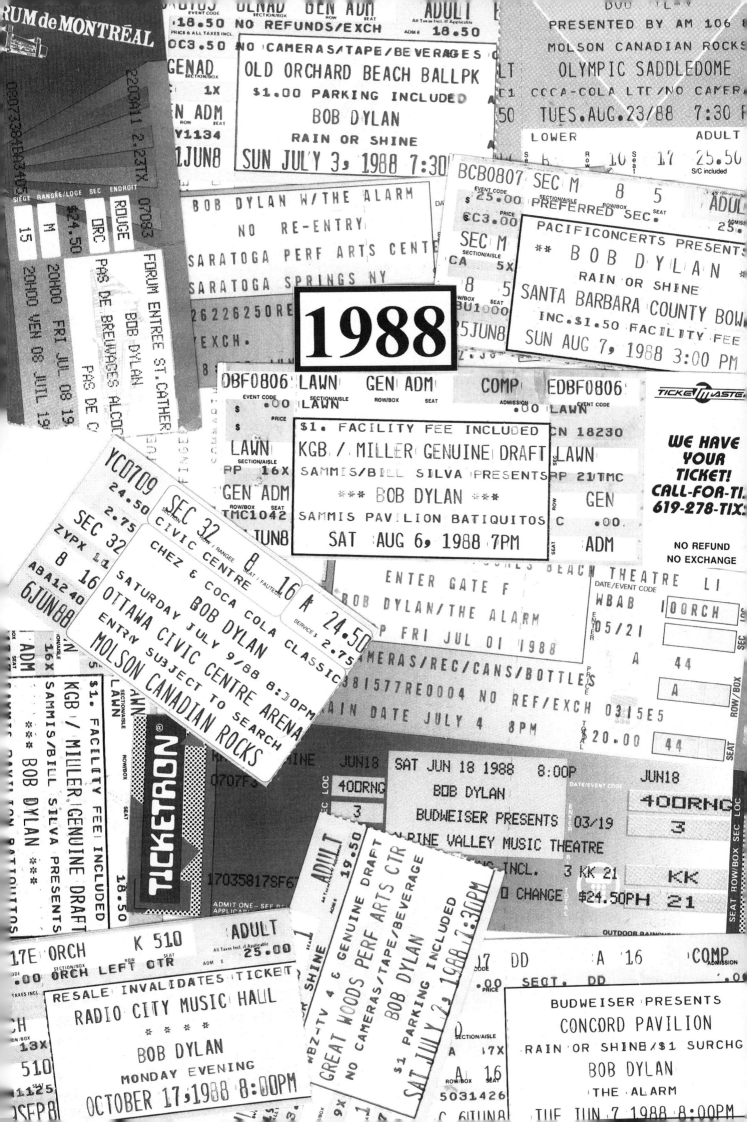

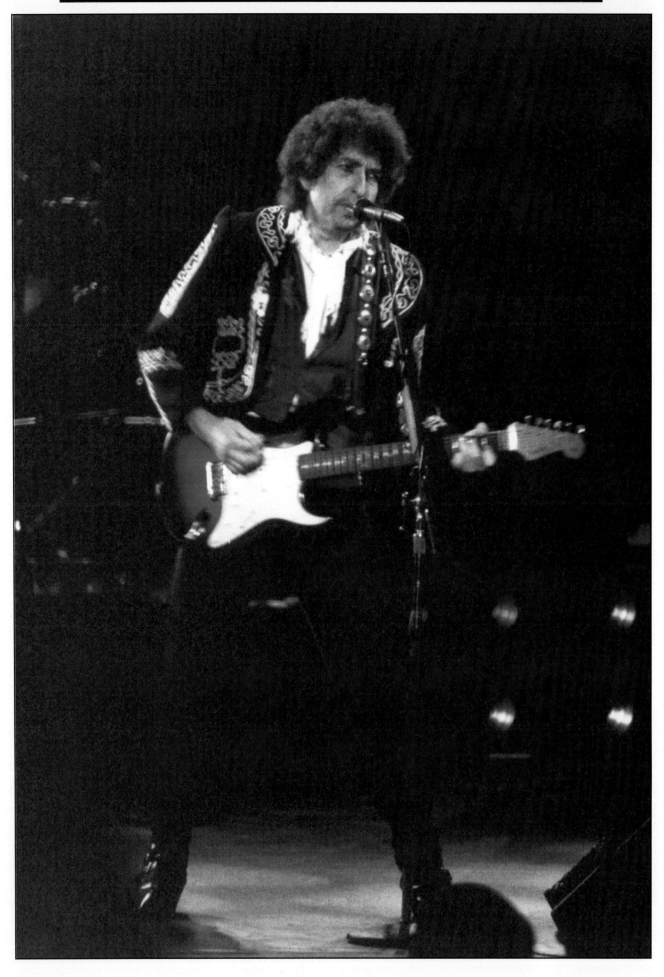

Canadaigua Rochester 28th June 1988

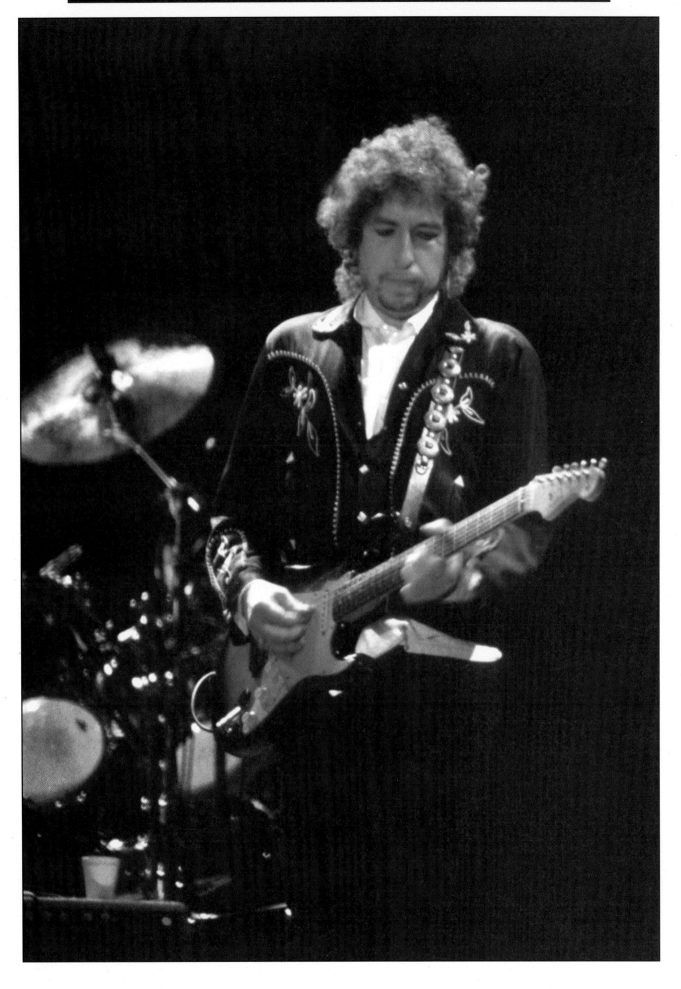

Portland Maine 3rd July 1988

Philadelphia
6th July 1988

With G.E. Smith
Hamilton Ontario
11th July 1988

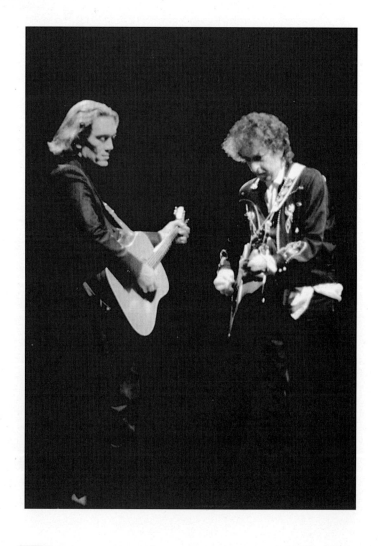

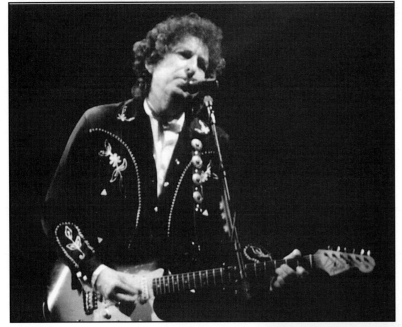

Jones Beach
New York
30th June
1988

Ottawa
9th July 1988

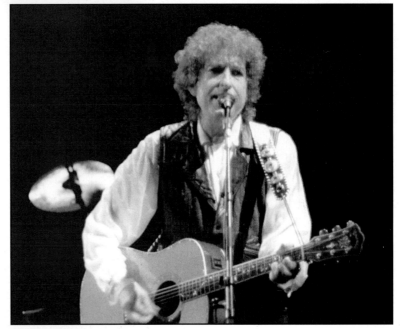

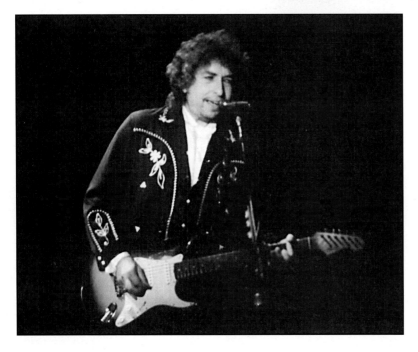

Holmdel
New Jersey
24th June 1988

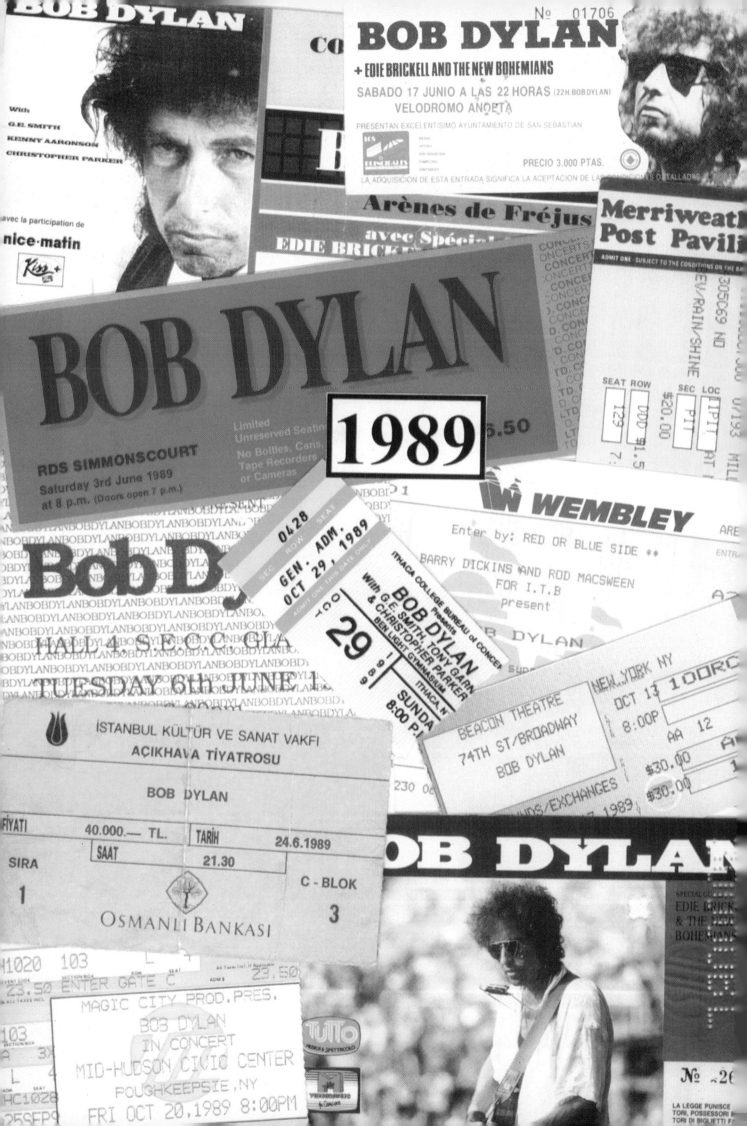

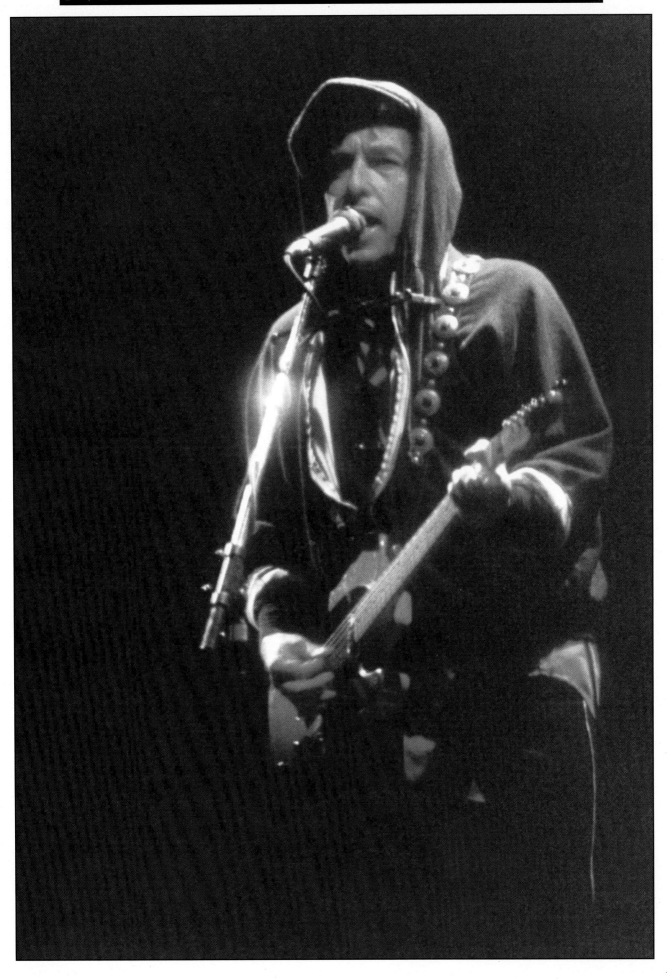

I'VE BEEN SHOOTING IN THE DARK TOO LONG

Dublin 3rd June 1989

Beacon Theatre New York City
13th Oct 1989

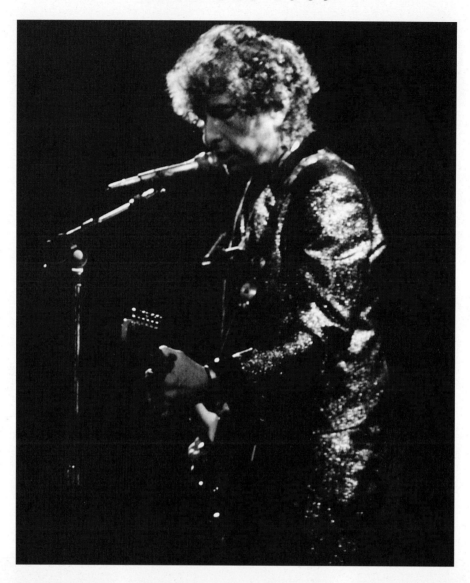

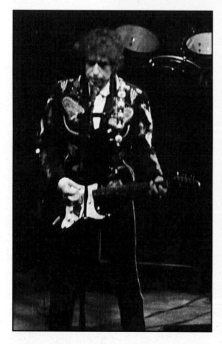 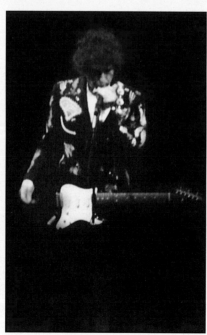 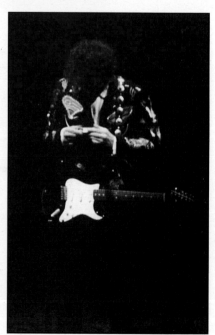

Beacon Theatre New York City 11th Oct 1989

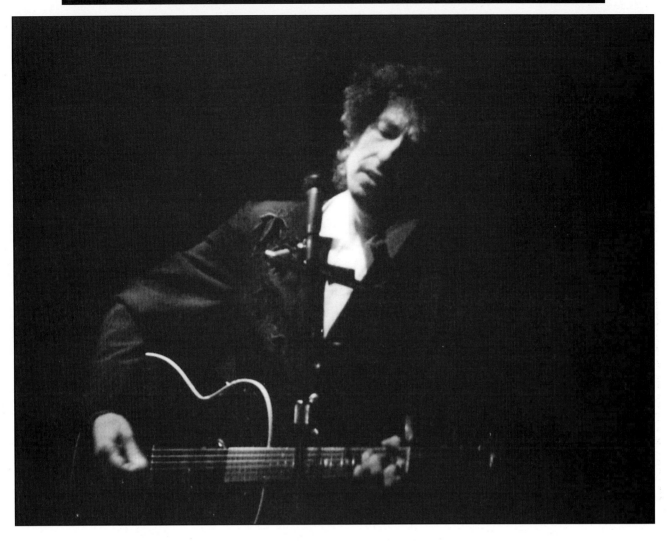

Boston Opera House 23rd October 1989

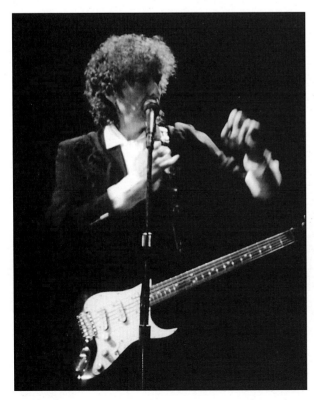
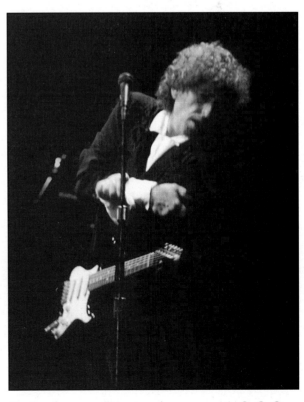

Boston Opera House 24th October 1989

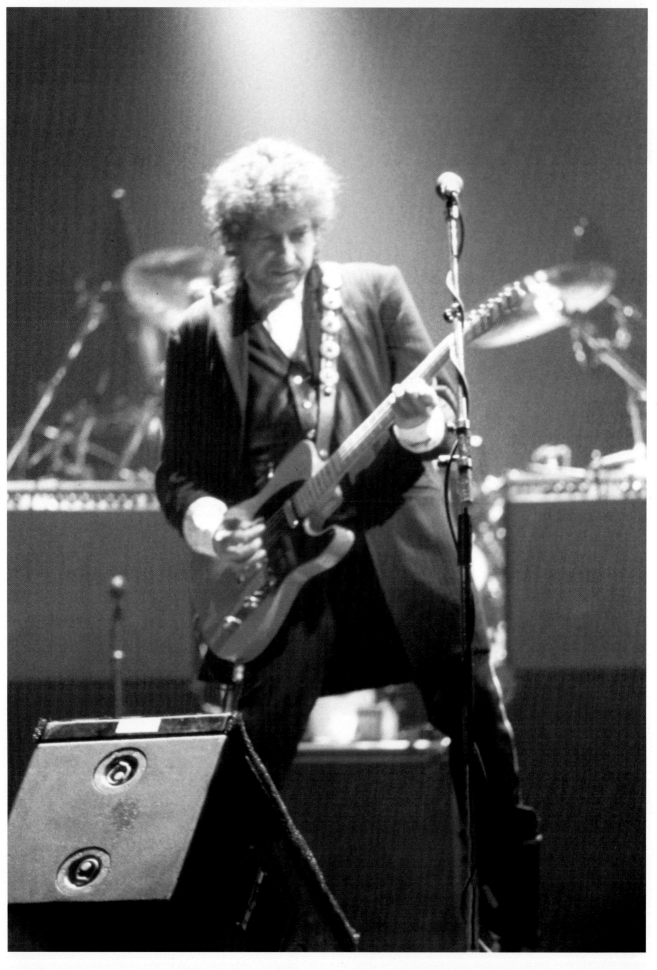

Wembley Arena London 8th June 1989

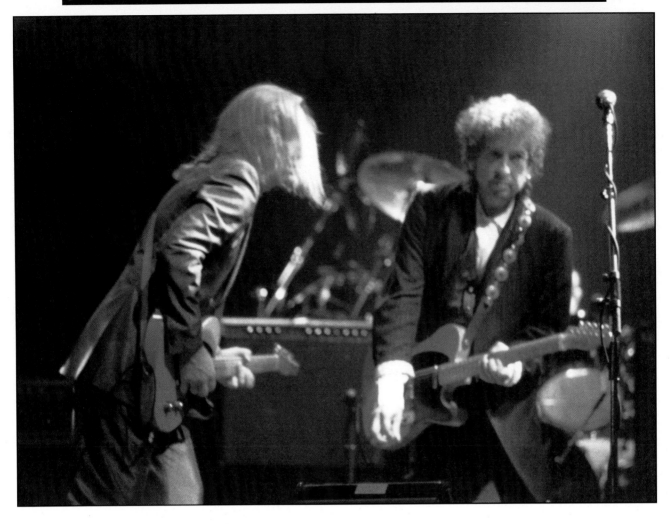

Wembley Arena London 8th June 1989

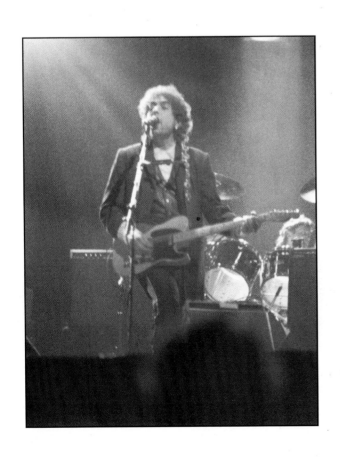

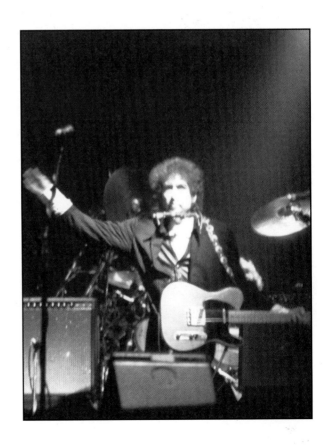

BOB DYLAN

AU GRAND REX

le 1er FÉV. à 20 h 30

With
G. E. Smith
Tony Garnier
Christopher Parker

Chérie

INTER CONCERTS

TOAD'S PLACE
300 YORK ST. NEW HAVEN

WPLR welcomes
BOB DYLAN
Fri. Jan. 12, 1990
$18.50
Showtime 8pm, Doors 6pm

No guaranteed seating.
Double proof of age required. No refunds.
Telephone: 777-7431

not valid without this stub.

BOB DYLAN
Fri. Jan. 12
$18.50

ODEON
Hammersmith

Telephone
01-748-4081/2

Please retain this

1712

Rank Theatres Limited VAT no. 425

I.T.B. PROUDLY PRESENTS

SEATING ARE

B O B D Y L A N + SUPPORT FRONT-STAL

25	H	6	3.2.90	SATURDAY	8.00	17.
BLOCK	ROW	SEAT	DATE	DAY	TIME	PRIC

№ 00983

BEACON THEATRE

74TH ST/BROADWAY

DATE/EVENT CODE

OCT 18 1 OORCH

BOB DYLAN

8:00PM

$30.0

NO REFUNDS/EXCHANGES

0925897RE0402 0315E11

:00PM THU OCT 18 1990

1990

18

PARAMOUNT PERFORMING ARTS CTR. SPFLD

AN EVENING WITH
BOB DYLAN

DATE/EVENT CODE

10123 12ORC

08:00P L/C

L/C N 3

REFUNDS/EXCHANGES $25.50

08:00P FRI OCT 12 1990 $26.00

N

3

ongress Centrum Berlin

Berlin 19 Bus 4, 10, 65, 69, 94 S-Bahn Westkreuz U-Bahn Kaiserdamm

Donnerstag, 5. Juli 1990 Beginn siehe Rückseite

Marek Lieberberg und Ossy Hoppe
in Cooperation mit concert concept präsentieren

BOB DYLAN
In Concert

Listahátíð í Reykjavík 1990

LAUGARDALSHÖLL

Miðvikudagur 27. júní kl. 21:0

KINGSTON COMM
MEMORIAL CENTRE

SEC 10

ROW J

SEAT 14

MAY 30
1990

Molson Canadian
Coca-Cola Class
B O B D Y
WEDNESDAY EVENIN
RESERVED SEAT
(incl. p.s.t. &
NO REFUNDS – NO

Management reserves right to refund and
No REFUNDS – NO
Not liable for accidents causing bodily harm. No can

Kontrolle
Donnerstag,
5. 7. 1990

BEACON THEATRE

BOB DYLAN

:00PM TUE OCT
5548236RE0402
NO REFUNDS EXCH

BOB DYLAN

KARSTEN JAHNKE UND NDR 2 PRÄSENTIEREN

NDR 2 OpenAir
STADTPARK

Hin und weg!
S1 bis Alte Wöhr,
Bus 118, 179 bis Dakarweg

HVV

Marek Lieberberg & Ossi Hoppe presents

BOB DYLAN
IN CONCERT

DIENSTAG, 3. 7. '90, 19.30 UHR
EINLASS: 18.30 UHR, FREILICHTBÜH
ECKE SAARLANDSTR./JAHNRING

KARTEN:
VVK: DM 40,– (INCL. MWST. + 10% VVK-G
AK: DM 46,– (INCL. 7% MWST.)

EH1013 ORCH LL 211 AD

EVENT CODE SECTION/BOX ROW SEAT

All Taxes Incl. if

$ 18.00 ORCH RIGHT CTR ADM.$ 1

PRICE & ALL TAXES INCL.

CC3.50

ORCH

SECTION/BOX BOB DYLAN

AC 12x * * *

LL 211 EISENHOWER HALL THEA

ROW SEAT

2NY417A WEST POINT, NY

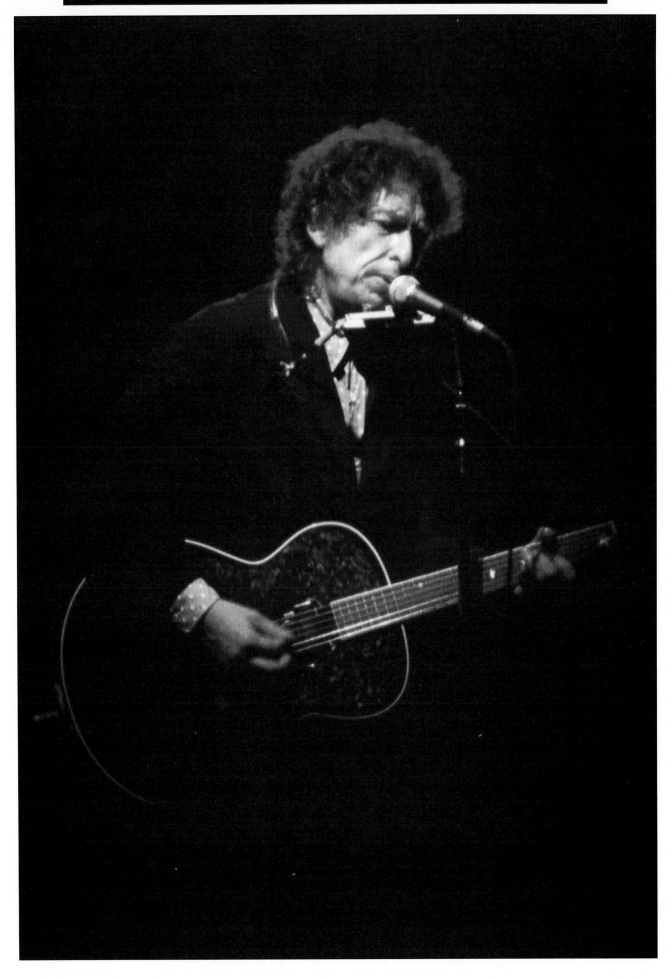

Hammersmith Odeon London 7th February 1990

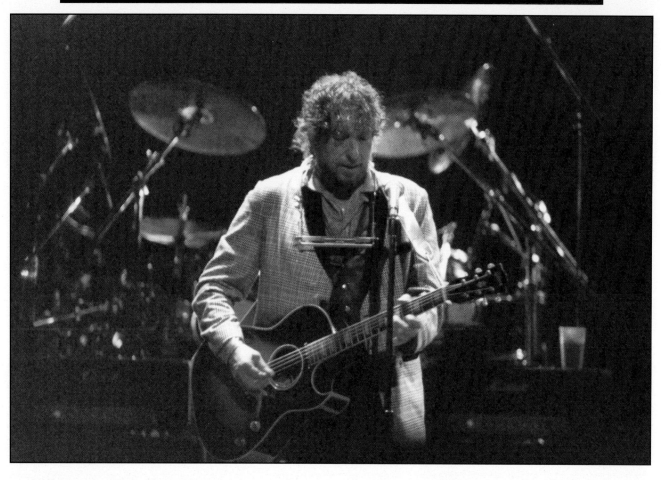

Beacon Theatre New York 18th Oct 1990

19th Oct 1990 16th Oct 1990

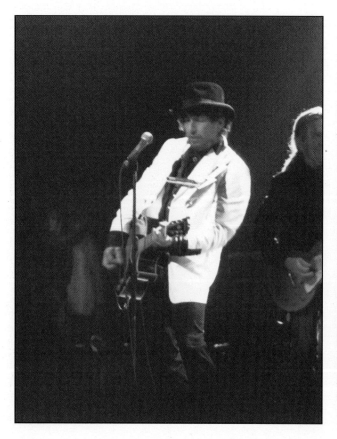

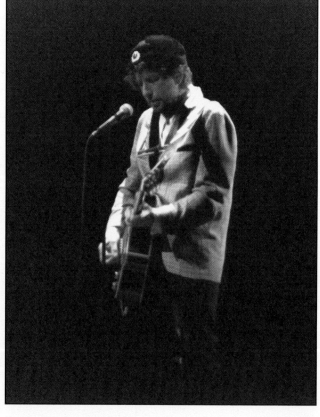

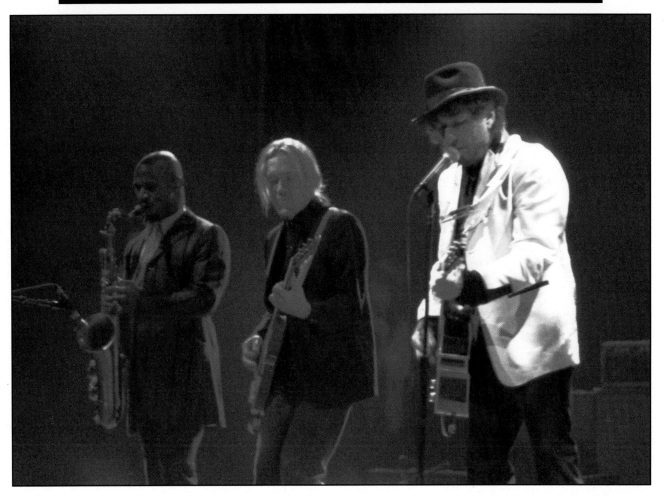

Beacon Theatre New York 19th Oct 1990
Dylan and G.E. Smith are joined by Carl Denson on sax

18th Oct 1990 17th Oct 1990

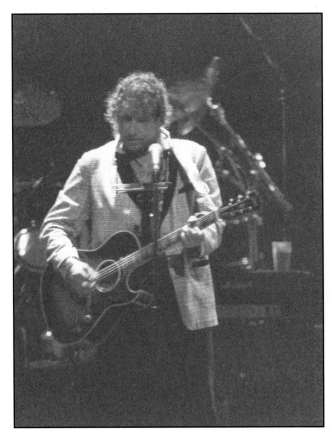

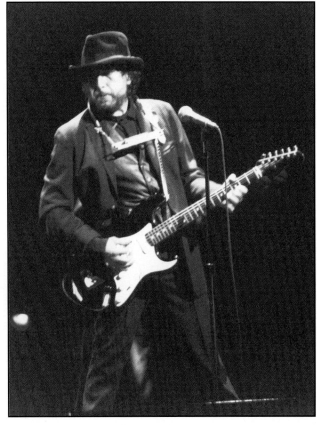

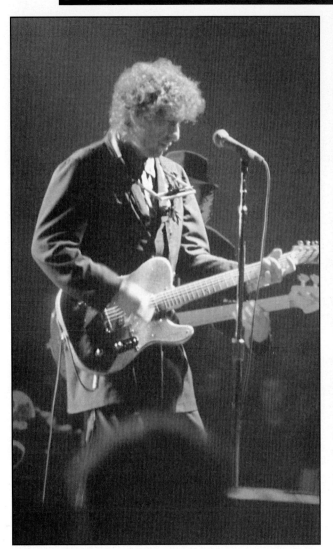

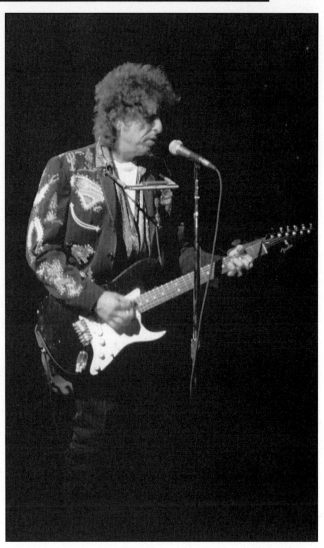

London

7th February 1990 4th February 1990

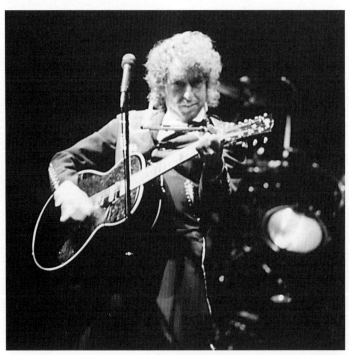

Paris 30th January 1990

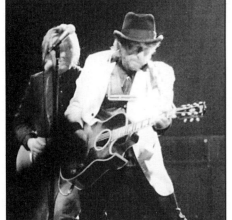

Beacon Theatre NYC 17th Oct 1990

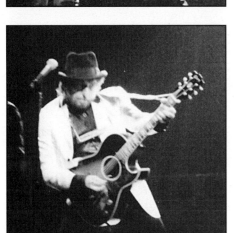

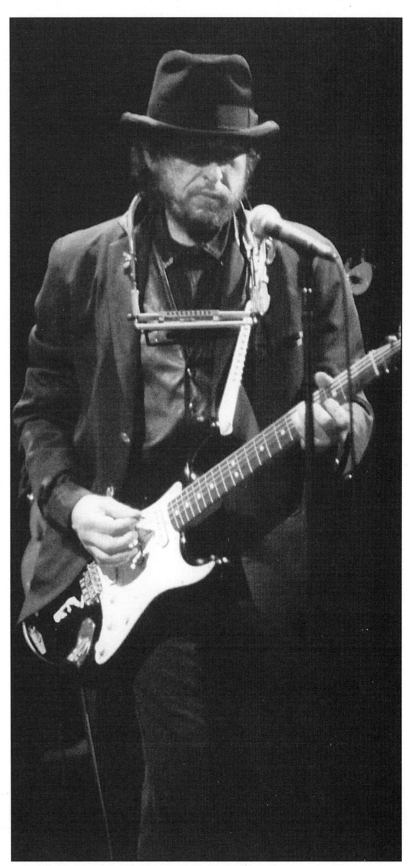

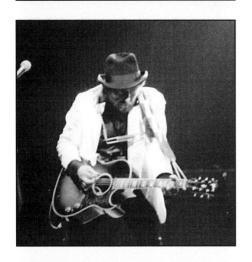

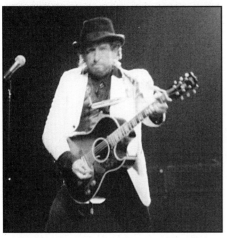

Beacon Theatre NYC 19th Oct 1990

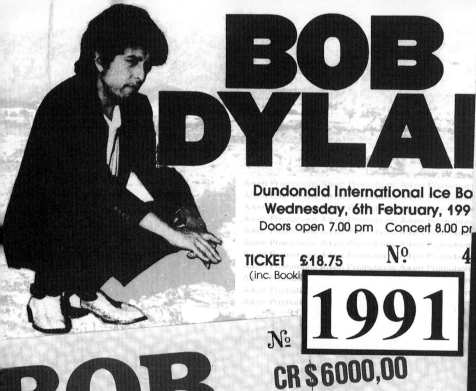

BOB DYLAN

Dundonald International Ice Bo
Wednesday, 6th February, 199
Doors open 7.00 pm Concert 8.00 pm

TICKET £18.75 № 4
(inc. Booki

BOB DYLAN

1991

№ CR $6000,00

BOB DYLAN

MINEIRINHO - 19/08/91 - 21:00h

PISTA

MILLS & NIEMEYER

3294

Dienstag, 18. Juni 1991 · 20.00 Uhr

ESSEN · GRUGAHALLE

Örtliche Durchführung: HPS Promotion
_____leitung: Marek Lieberberg Konzertagentur Gr

ODEON
_____mersmith

Telephone
081-748-4081/2

Please retain thi

2312

Rank Theatres Limited VAT no. 425

SCHALLPLATTENGESCHÄFT
MUSIKLADEN **The Legend**

RAIFFEISEN
eXlub

BOB DYLAN

Olympiahalle Innsbruck

14.6.91 W Beginn: 20 Uhr
Einlaß: 19 Uhr

Tournee: V I E N N A CE OP HS CF EB RP TS SF

_TB PROUDLY PRESENTS

D Y L A N + GUESTS

15.2.91
DATE

FRONT—STA

FRIDAY
DAY

8.00 19
TIME

SEATING ARE

PRIC

DYLAN
Raindogs
8 00 PM
_305

BOB DYLA

THE
POINT
DEPO

MTK-Stadion

C LELÁTÓ ÜLŐHELY

C 12

1991. június 12-én, szerdán este 8 órakor

Bob Dylan

MULTICKET '91

**Limited Unreserved
Seating**
Official Merchandising

Ti
£1

5th
Doors Open
Concert 8

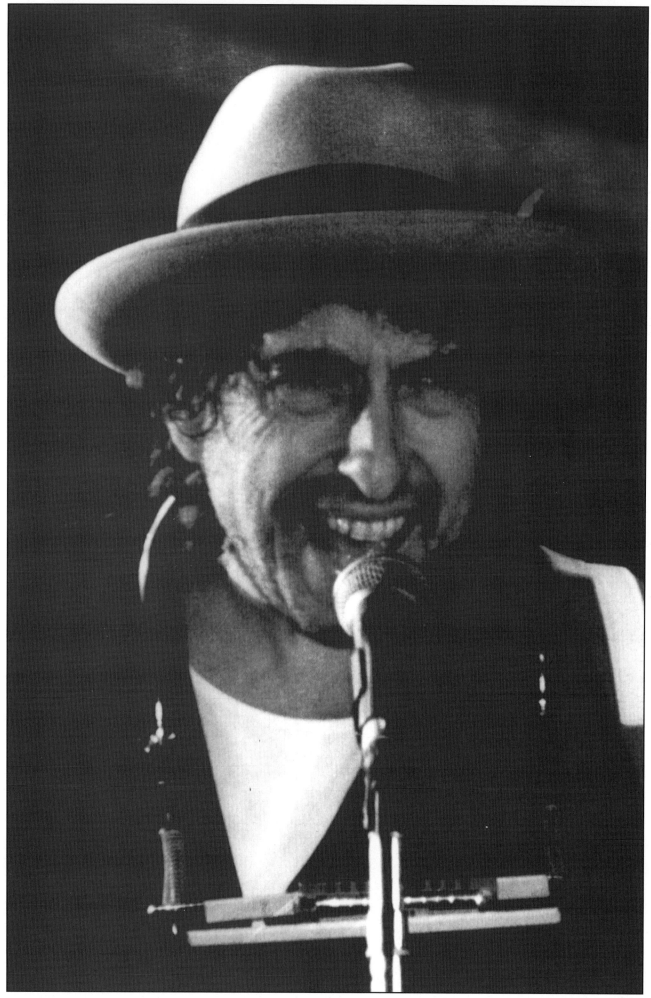

Budapest Hungary 12th June 1991

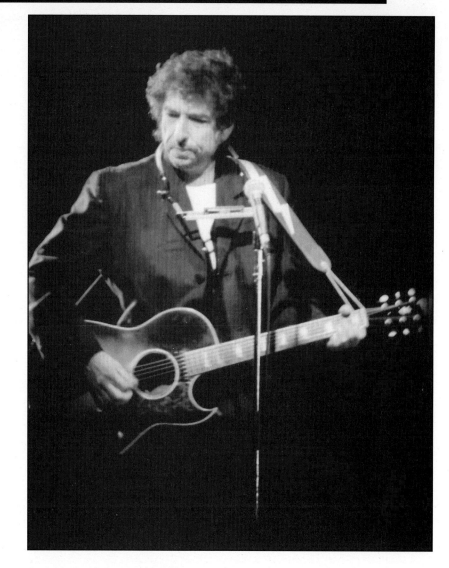

Belgrade
Yugoslavia
11th June 1991

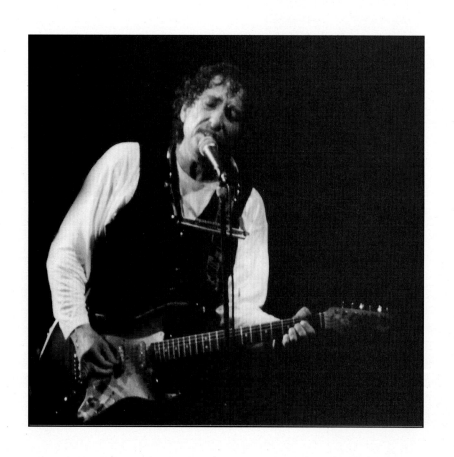

The Palaeur
Rome
6th June 1991

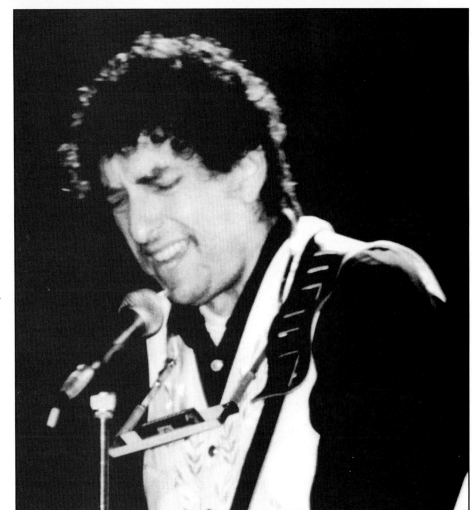

Essen
Germany
18th June 1991

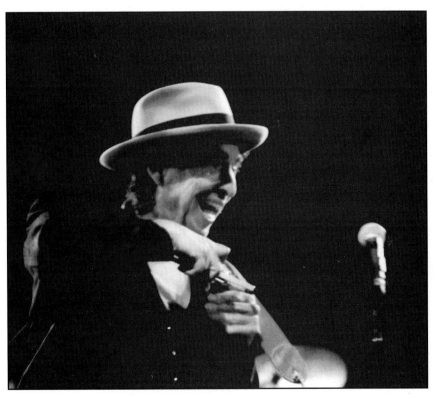

Ljubljana
Yugoslavia
10th June 1991

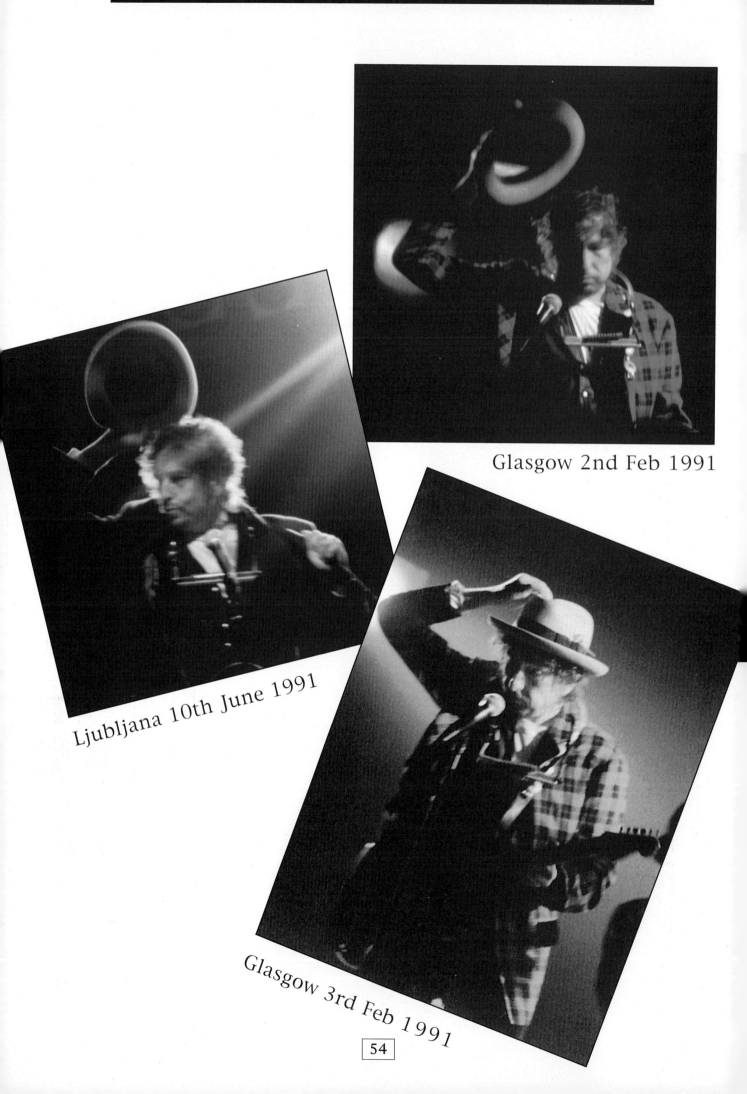

Glasgow 2nd Feb 1991

Ljubljana 10th June 1991

Glasgow 3rd Feb 1991

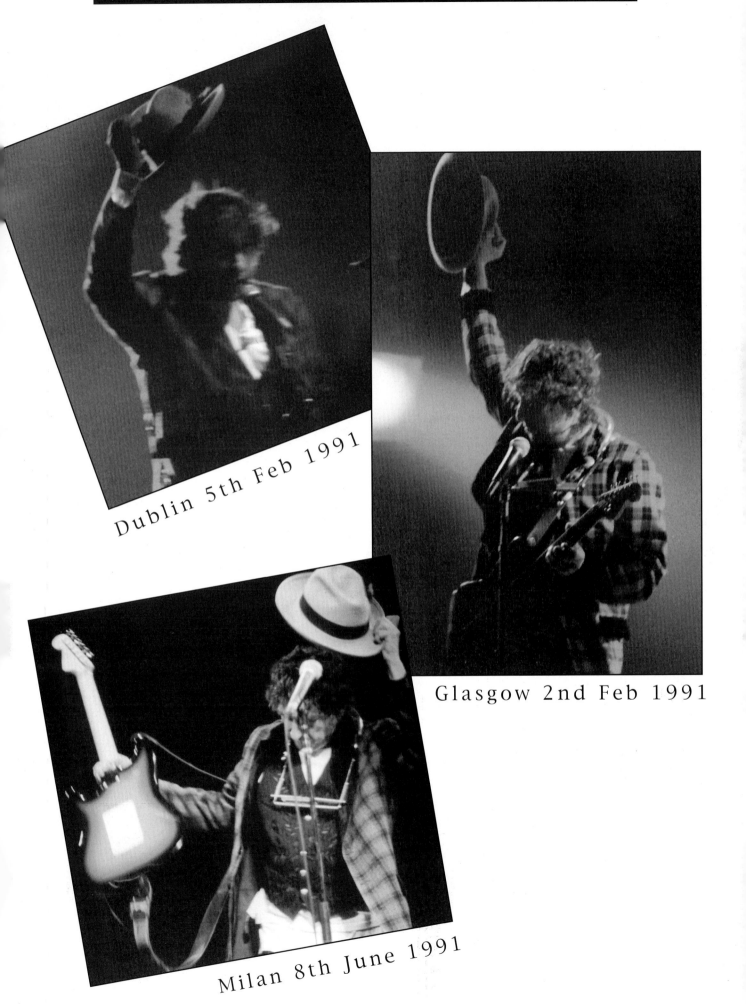

Dublin 5th Feb 1991

Glasgow 2nd Feb 1991

Milan 8th June 1991

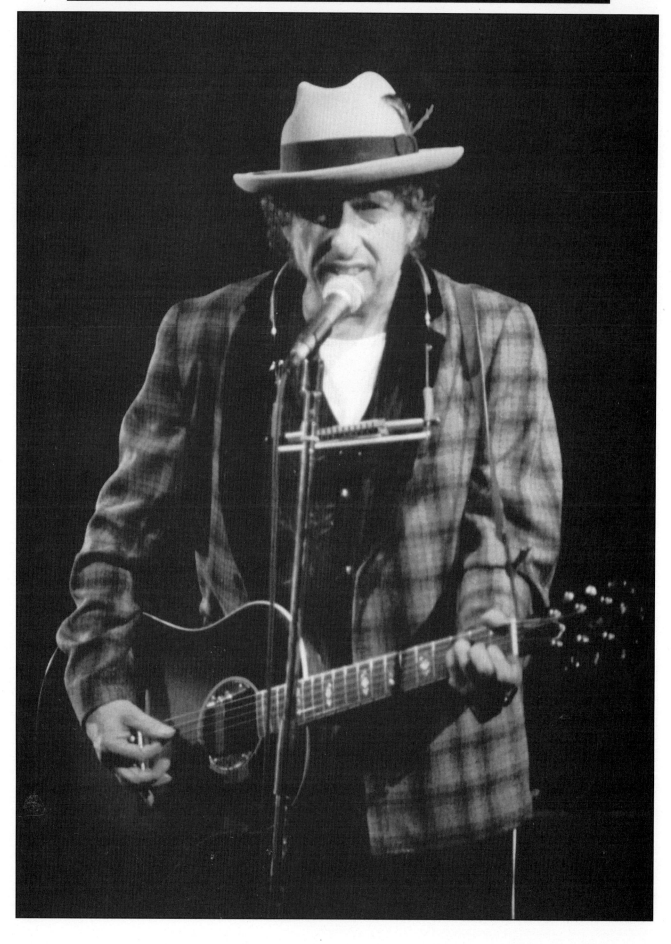

Milan 8th June 1991

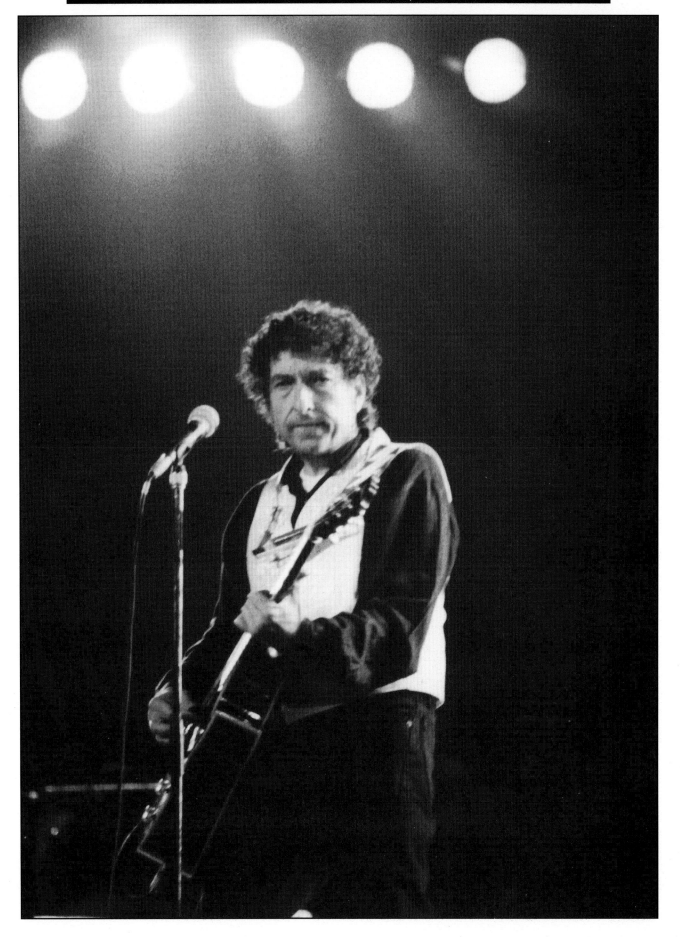

Essen 18th June 1991

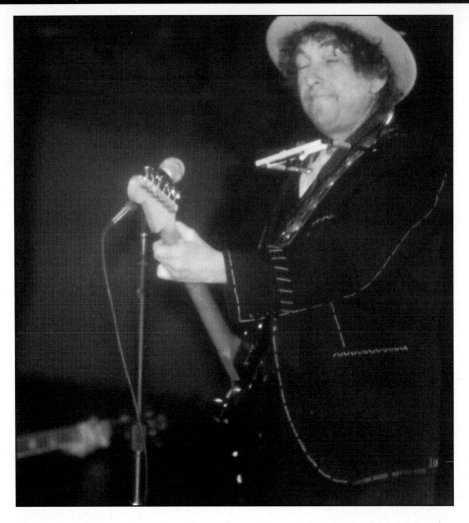

Dundonald Ice Bowl Belfast 6th Feb 1991

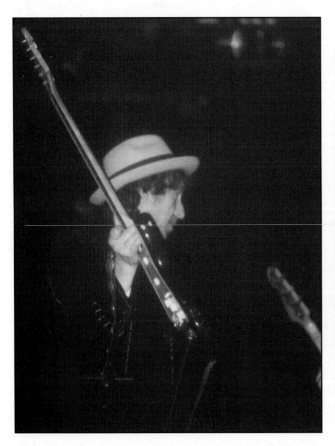

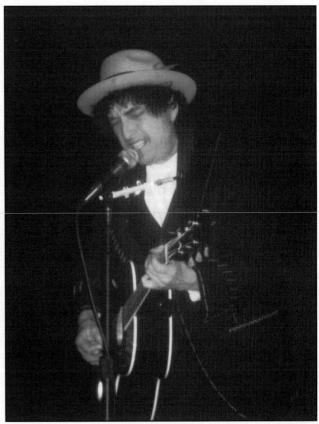

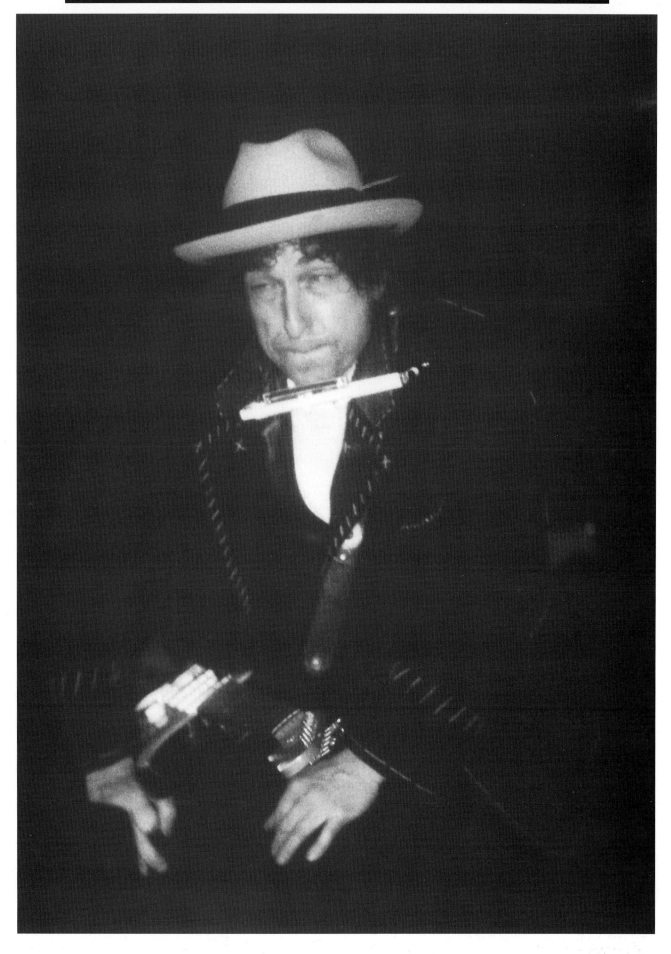

Dundonald Ice Bowl Belfast 6th Feb 1991

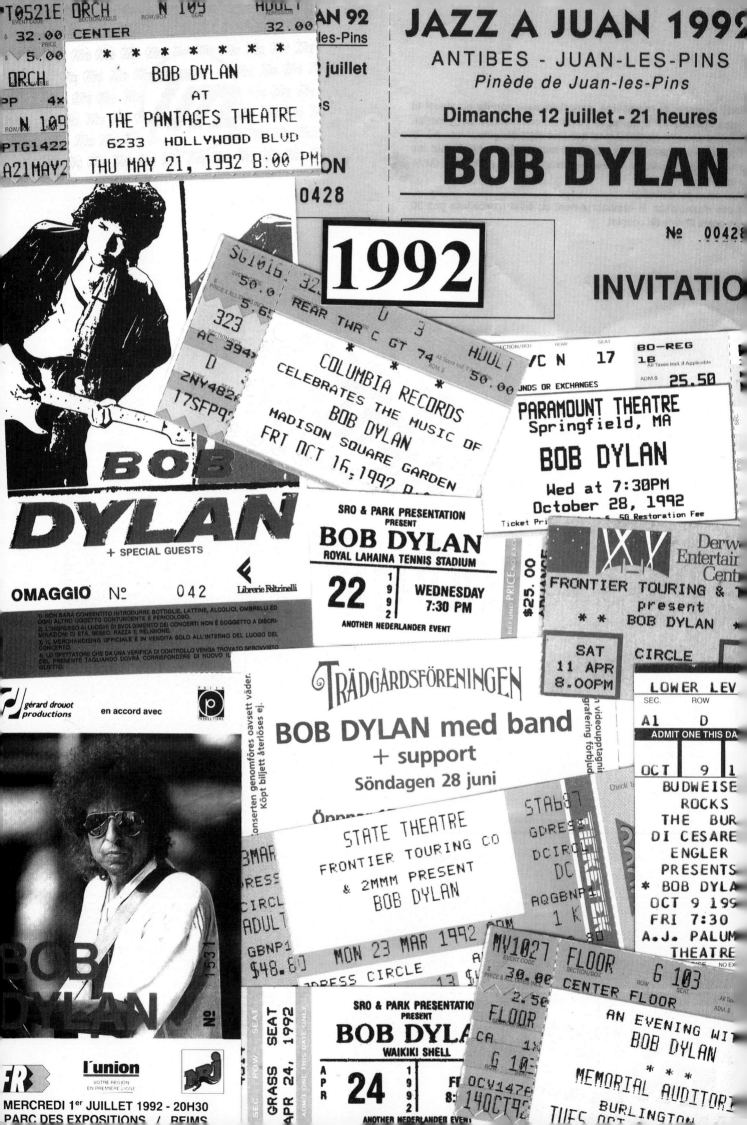

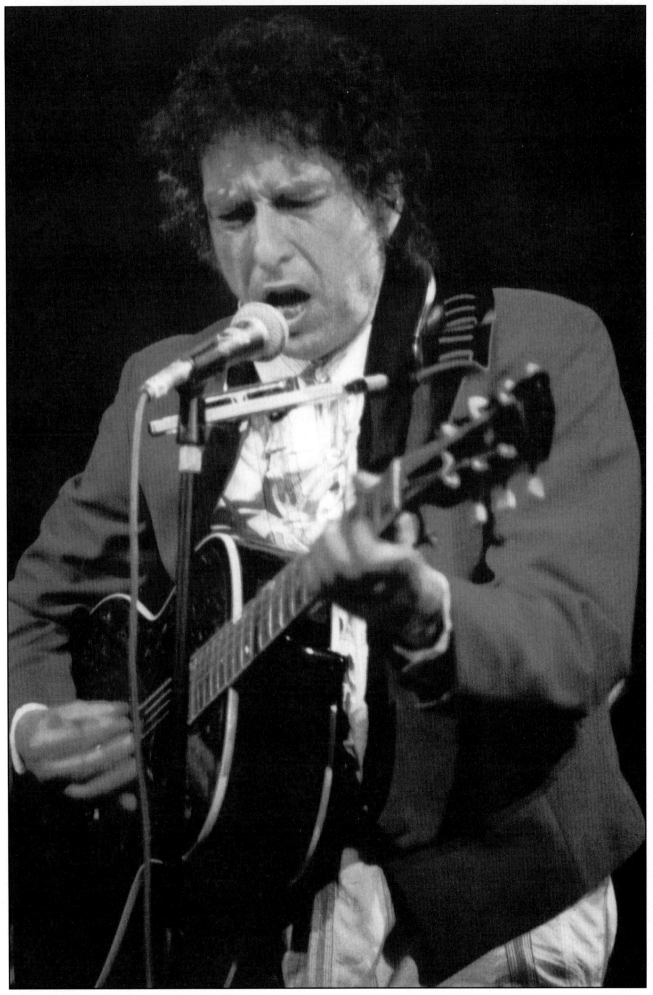

Dunkirk France 30th June 1992

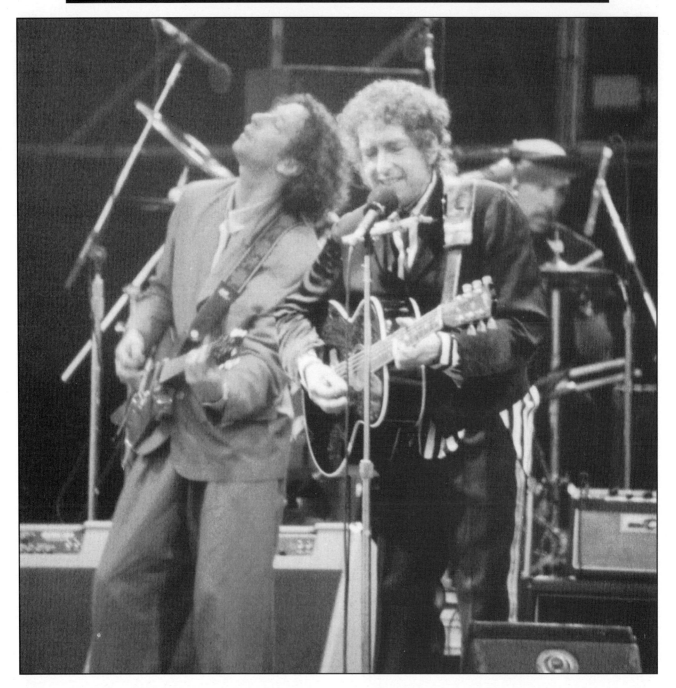

Belfort France 2nd July 1992

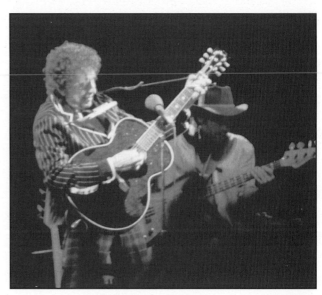

Genoa Italy 4th July 1992

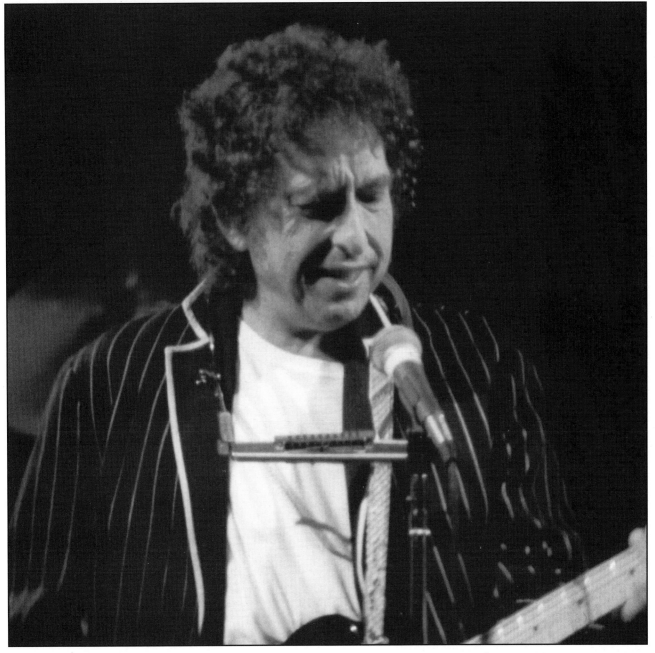

Merano Italy 7th July 1992

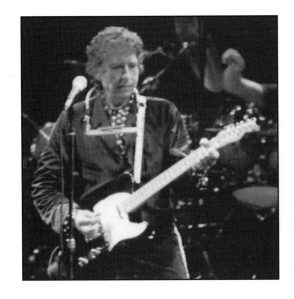

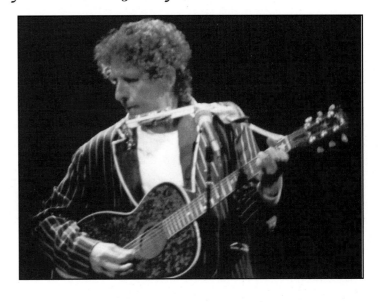

Reims 1st July 1992

Merano 7th July 1992

My 1992 tour had started with a tedious journey through France trying to avoid the roadblocks and get to the concerts on time. Much of the country was affected by the French farmers' protests, usually in the form of piles of burning tyres set up on the main roads to cause as much disruption as possible. So from Dunkirk to Reims and then on to Belfort you were wondering if you would arrive in time for the concert, or if you would have to cancel the journey and try and make it to the following day's show instead. In the end we did make it through all the obstacles put in our way.

Then it was long train journeys from France through Switzerland and into Italy for the first of the four Italian shows. And after many miles of driving through Italy it was back into Switzerland for the concert in Leysin. When we finally arrived in Aigle, a small village at the foot of the mountains, we were informed that this was the closest you could get to Leysin by car. The concert was up in the mountains and you had to take a slow train journey for an hour and then walk for another half an hour to reach the festival site. Now I had been looking forward to this tour because it ended in the South of France, and I'd already planned to stay on there for a few days after the tour finished, but I was getting pissed off with all the travelling and wasn't looking forward to this monotonous trek up into the mountains to sit in a wet muddy field.

In a field next to where we'd parked the car, I noticed some helicopters landing and taking off every 5 or 10 minutes and went over to ask what was happening. It turned out that you could take a helicopter to the concert and be there in 5 or 6 minutes. Now I ask you, if you were given the option of sitting on a train for an hour, then walking for half an hour in the rain, or, climbing into this helicopter and arriving in style 5 minutes later, would that be a difficult choice for you ? Besides how many Dylan shows do you go to where you have the opportunity to take a helicopter to the concert. So I paid for my ticket and we took off up into the mountains.
. Definitely a nice way to travel to a concert !

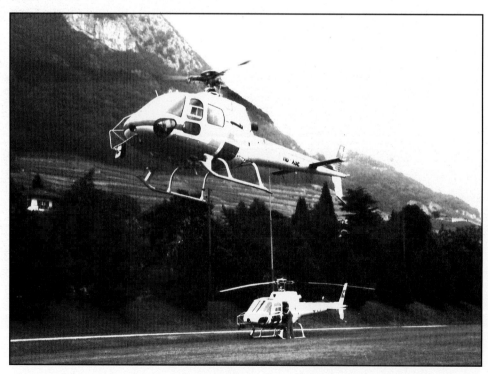

A nice way to travel to a Dylan concert

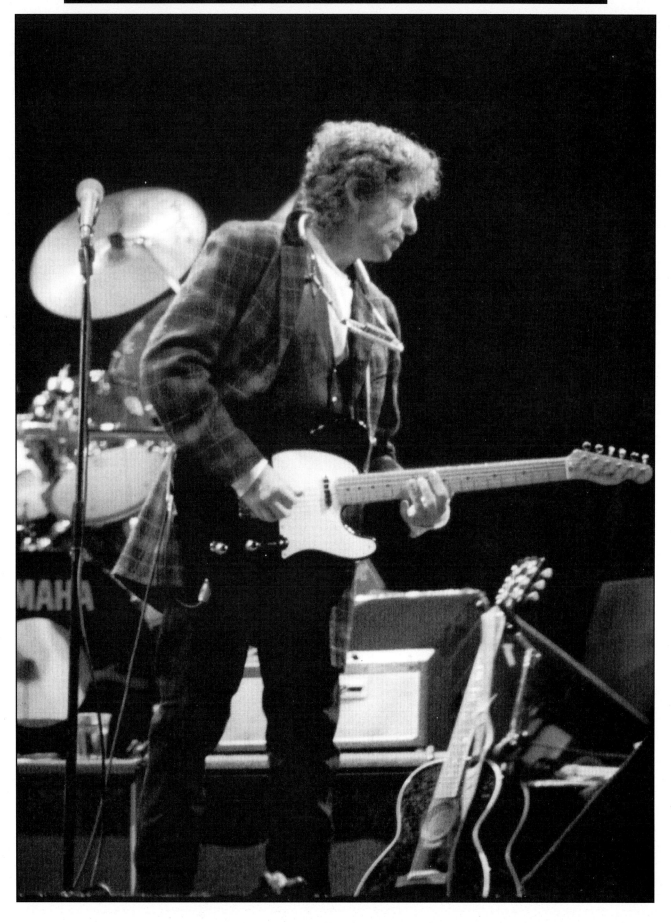

A clear view of Dylan onstage at Leysin, Switzerland, 10th July 1992

(During parts of the show he was hidden from view by passing clouds)

Juan les Pins was one of my all time favourite settings for a Dylan concert. It was the opening show of a two week festival, and the stage had been built around some palm trees at the edge of the beach with the warm Mediterranean sea lapping at the area just behind the stage.

During the afternoon the gates were open and anyone could walk in to the concert area, so we got to watch the band rehearsing and doing their soundcheck for the show later on that evening. I was even given a job after the soundcheck of guarding the guitars on stage and was told not to let anyone onto the stage unless they had the relevant pass.

Just my luck, the first time I'm allowed onstage with my camera at a Dylan show, but unfortunately the show doesn't start for another 3 hours.

J.J. arriving for the soundcheck.
Juan les Pins 12th July 1992

After a great concert to end the tour, 7 or 8 of us were sitting at an outdoor restaurant later that evening having a meal. On the opposite corner of the town square about 30 metres from where we were, some guys were busking, and a small crowd had gathered to listen to them. I thought one of the buskers looked familiar and went over to take a closer look. It was John Jackson!

Just a few hours after playing onstage with Dylan, he had joined a group of Irish guys who were spending the summer working in hotels in the area.

'Bucky' Baxter borrowed one of the guitars and joined in too, while other members of the band and crew watched the proceedings, including Charlie Quintana, Ian Wallace, Tony Garnier and Victor Maimudes.

Quintana walked the short distance back to the hotel where the band and Dylan were staying

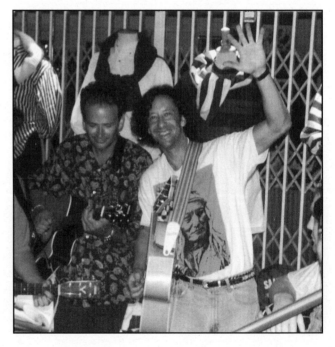

J.J. and 'Bucky' Baxter
later that evening

and returned with his drumsticks to join in the fun. We found out later that Dylan had asked where he was going, and when Quintana told him the band were busking on a street corner, Dylan asked if they were making much money.

A short time later, Dylan, along with his bodyguard/minder Jim Callaghan came over to watch. Even hiding behind his baseball cap and dark glasses Dylan wasn't comfortable with the cameras and video camera, and went back to the hotel after about 5 minutes.

The rest of the band carried on playing until 3 or 4 in the morning, covering quite a mixture of songs including some by Van Morrison, The Band, and even a few Dylan numbers.

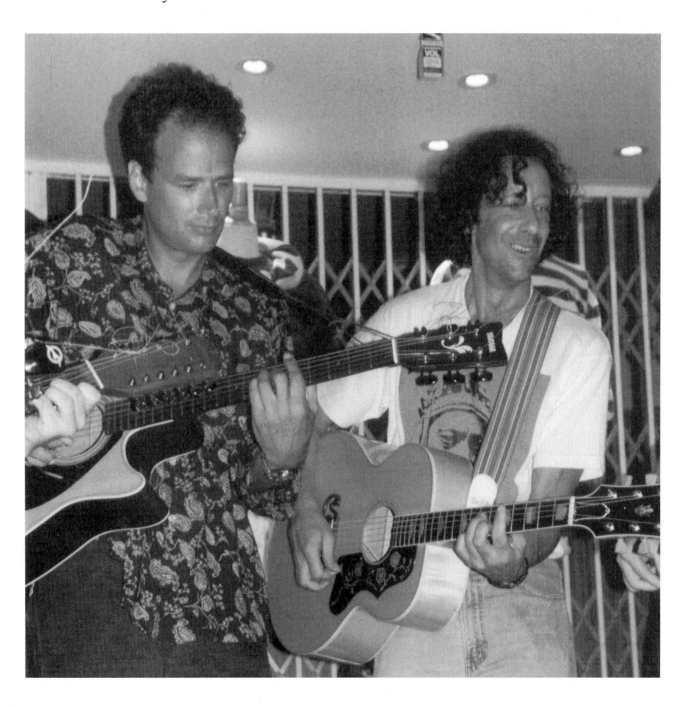

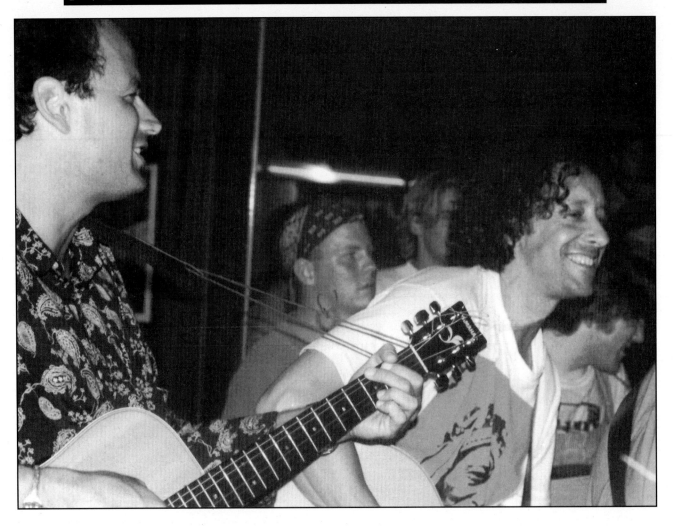

Bucky Baxter and John Jackson

Tony Garnier didn't join in the busking, but was happy to contribute when the hat was passed round!!

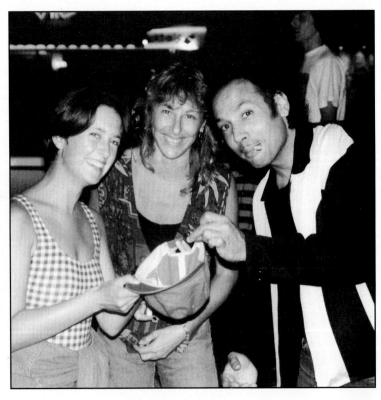

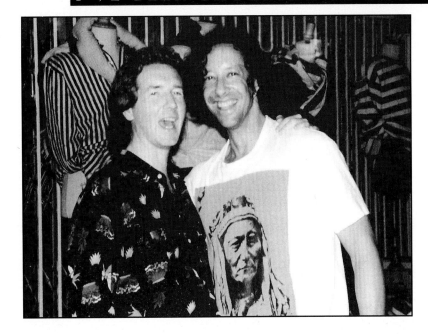

John Hume
and
John Jackson

Charlie Quintana
John Hume
and 'Bucky' Baxter

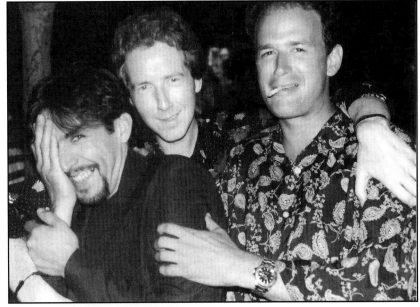

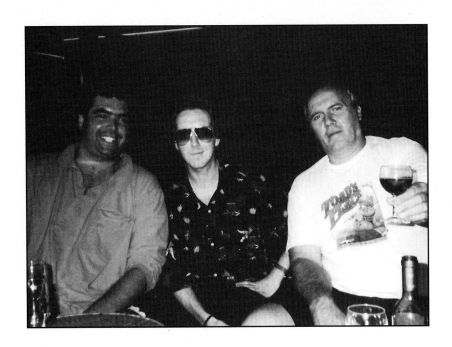

Bob Bettandorf
John Hume
and Jim Callaghan

Three nights after Dylan's concert, Tracy Chapman was playing at the same venue as part of the 'Jazz à Juan' festival and I decided to go along. Dylan was still in town, and also came to the concert with Dave Stewart (who had joined him onstage for one song during his show). After the show Dylan and Dave Stewart and some friends sat in the front garden of their hotel for a few late night drinks, in clear view of anyone walking by the hotel.

The next day a friend and myself were flying from Nice back to the U.K. Shortly after arriving at Nice airport an American tourist came over to speak to us. Having noticed my friend was wearing a Dylan T shirt, he told us that he'd just seen Dylan downstairs at one of the check-in desks. I quickly rummaged through my luggage hoping to find a camera with some film left in it, and went downstairs to look around.

After walking the full length of the airport lounge glancing at hundreds of passengers in the vain hope of seeing Dylan among them, I'd almost given up hope when I spotted him at the end of the lounge area. The woman with Dylan noticed me pointing the camera at him, so I had to move out of her view and try to take some quick shots with the last few frames of film I had left. I'd just managed to get a couple of shots when there was a power cut, the lights went out and the place was in darkness.

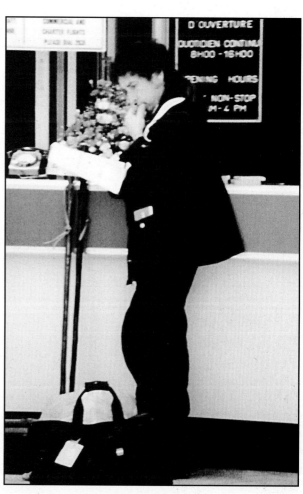

Dylan at Nice Airport 16th July 1992

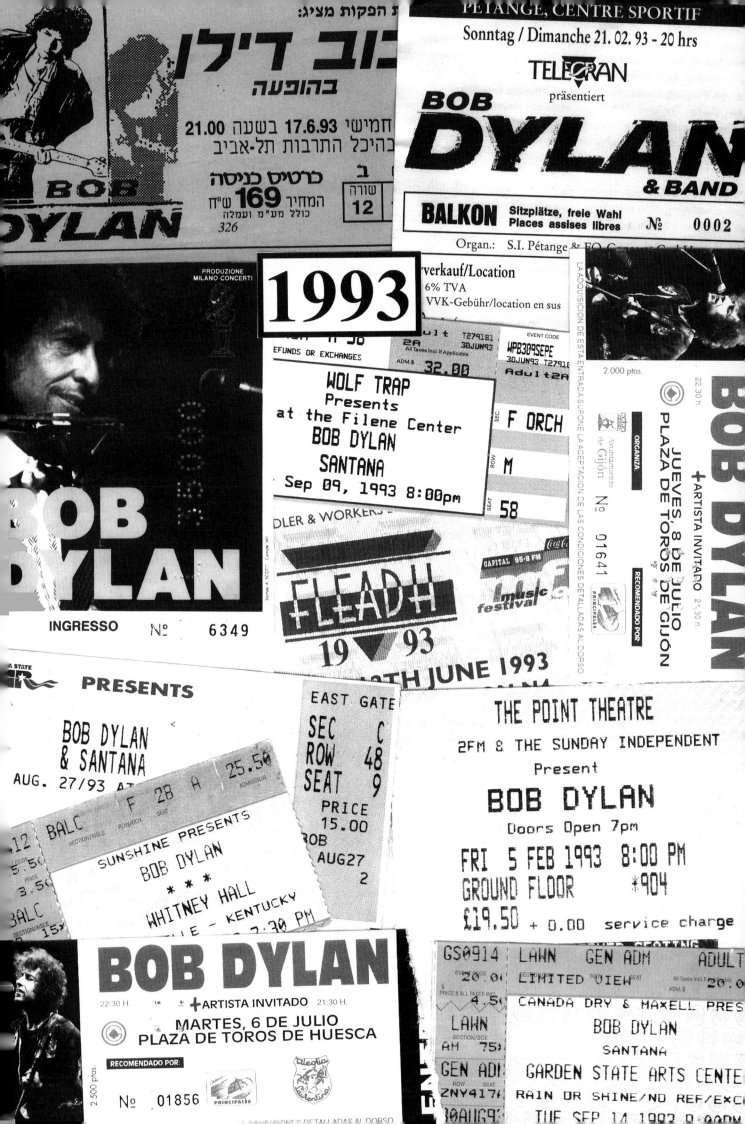

בוב דילן
בהופעה

21.00 בשעה 17.6.93 חמישי
בהיכל התרבות תל-אביב
כרטיס כניסה
169 המחיר ש״ח
כולל מע״מ ועמלה
326

שורה
12

BOB DYLAN

PÉTANGE, CENTRE SPORTIF

Sonntag / Dimanche 21. 02. 93 - 20 hrs

TELECRAN
präsentiert

BOB DYLAN
& BAND

BALKON Sitzplätze, freie Wahl
Places assises libres № 0002

Organ.: S.I. Pétange & EO Concert G.b.H.

verkauf/Location
6% TVA
VVK-Gebühr/location en sus

PRODUZIONE
MILANO CONCERTI

BOB DYLAN

INGRESSO № 6349

1993

EFUNDS OR EXCHANGES

WOLF TRAP
Presents
at the Filene Center
BOB DYLAN
SANTANA
Sep 09, 1993 8:00pm

DLER & WORKERS

T279181 30JUN93
2A All Taxes Incl. If Applicable
ADM.$ 32.00
Adult2A

EVENT CODE
WPB309SEPE
30JUN93 T2791B

SEC. F ORCH
ROW M
SEAT 58

FLEADH
19 93

CAPITAL 95·8 FM
music festival

9TH JUNE 1993

2.000 ptas.
22.30 h.

LA ADQUISICION DE ESTA ENTRADA SUPONE LA ACEPTACION DE LAS CONDICIONES DETALLADAS AL DORSO

ORGANIZA
Ayuntamiento de Gijón
RECOMENDADO POR
PRINCIPALES

BOB DYLAN
+ARTISTA INVITADO 21.30 h.

JUEVES, 8 DE JULIO
PLAZA DE TOROS DE GIJON

№ 01641

STATE
PRESENTS

BOB DYLAN
& SANTANA

AUG. 27/93 A

25.50
ADMISSION
F 28 A
SEAT

EAST GATE

SEC C
ROW 48
SEAT 9

PRICE
15.00

BOB
AUG27
2

BALC
SECTION/AISLE ROW/BOX

12

SUNSHINE PRESENTS
BOB DYLAN
* * *
WHITNEY HALL
— KENTUCKY
7.30 PM

THE POINT THEATRE
2FM & THE SUNDAY INDEPENDENT
Present

BOB DYLAN

Doors Open 7pm

FRI 5 FEB 1993 8:00 PM
GROUND FLOOR *904
£19.50 + 0.00 service charge

BOB DYLAN
+ARTISTA INVITADO 21:30 h.

22:30 H.

MARTES, 6 DE JULIO
PLAZA DE TOROS DE HUESCA

RECOMENDADO POR:

PRINCIPALES
Alegria

2.500 ptas.
№ 01856

GS0914 LAWN GEN ADM ADULT
EVENT CODE LIMITED ROW VIEW SEAT
20.0
PRICE & ALL TAXES INCL. All Taxes Incl. ADM.$ 20.0

LAWN
SECTION/BOX
AH 75

GEN AD
ROW
SEAT
ZNY417

CANADA DRY & MAXELL PRES

BOB DYLAN
SANTANA

GARDEN STATE ARTS CENTE

RAIN OR SHINE/NO REF/EXC

THE SEP 14 1993

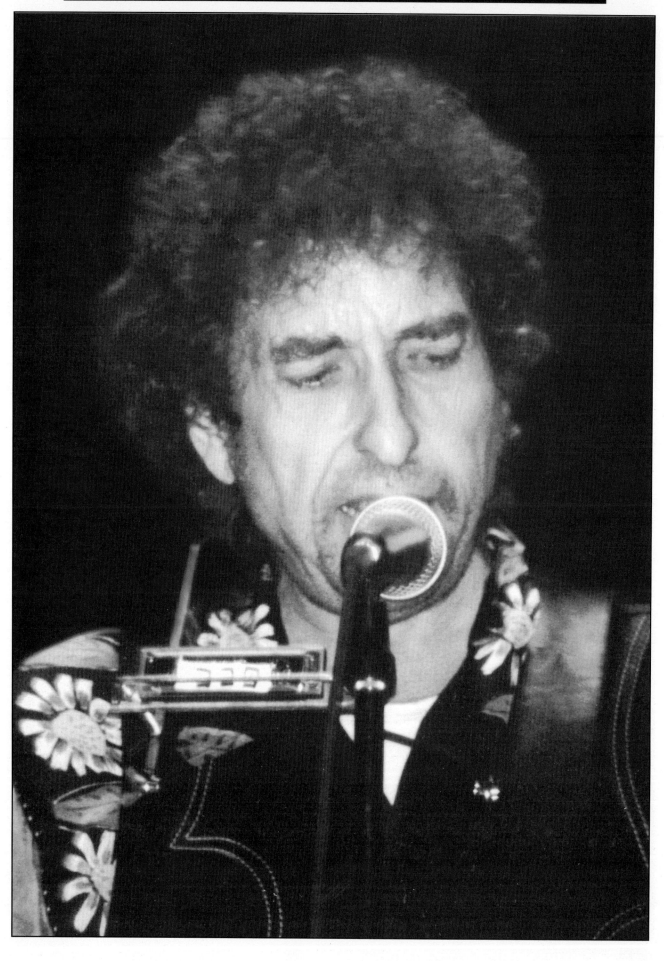

Gijon Spain 8th July 1993

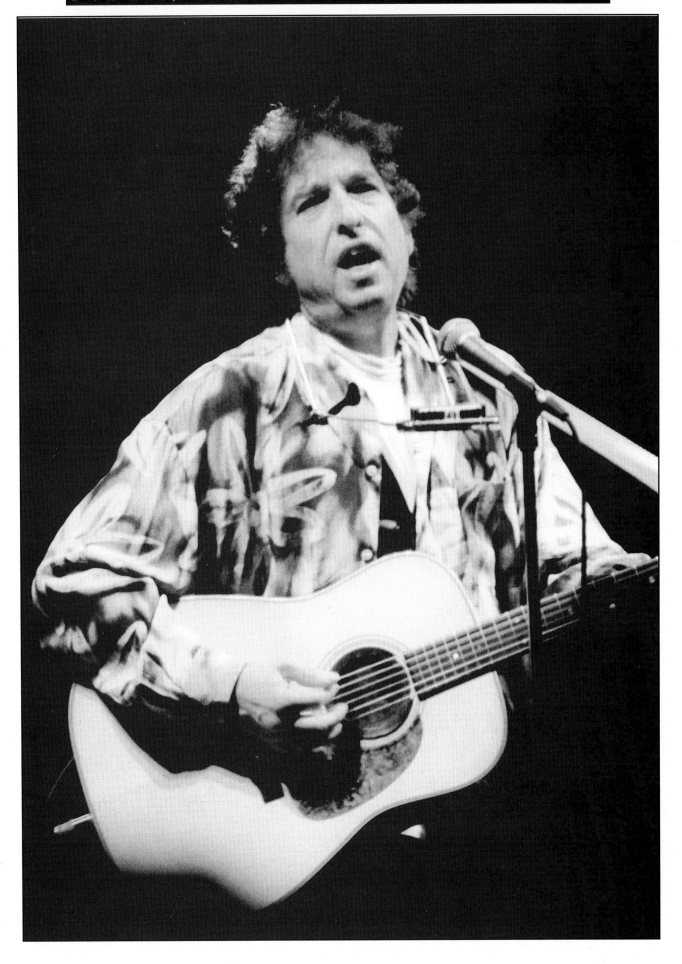

Eindhoven Holland 17th Feb 1993

73

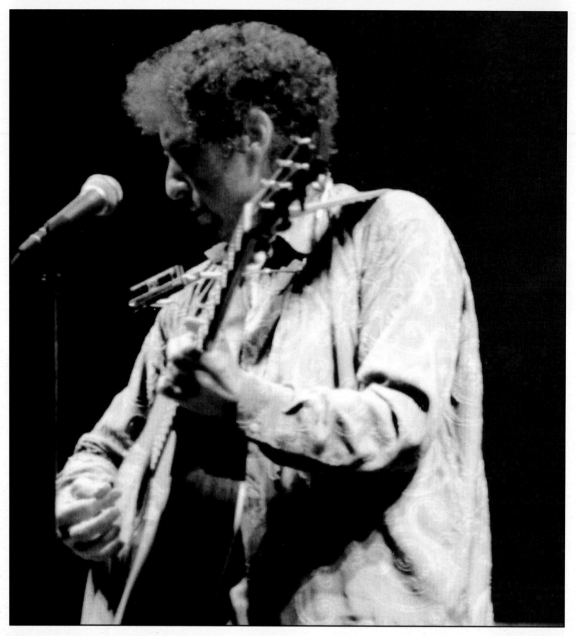

Hammersmith London 12th Feb 1993

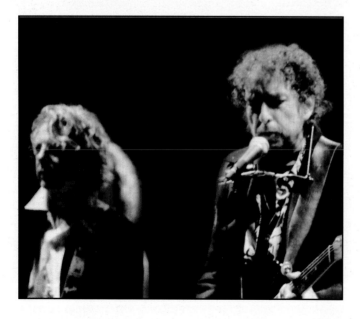
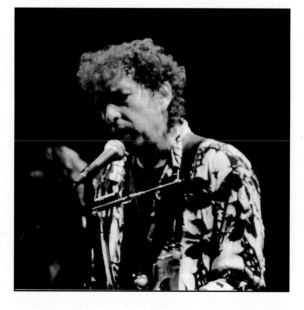

With Dave Stewart London 13th Feb 1993

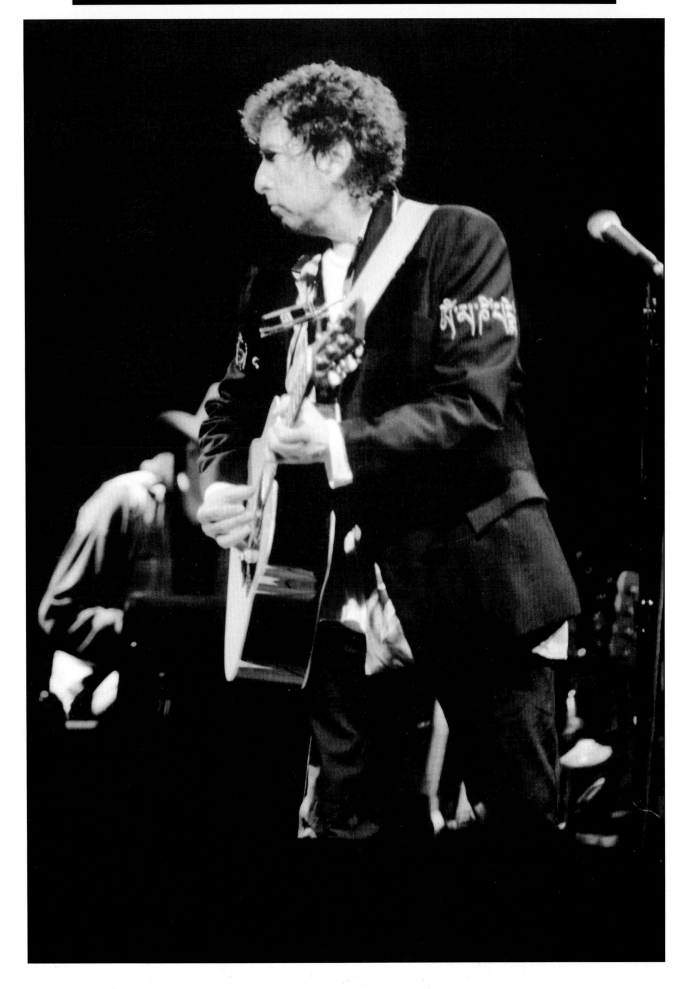

Maysfield Leisure Centre Belfast 25th Feb 1993

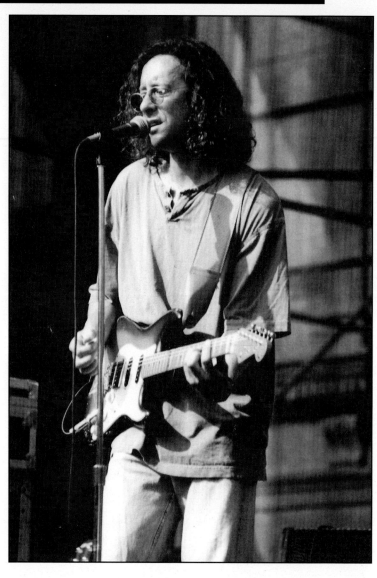

John Jackson singing
'Series of Dreams'
at the soundcheck for the
Barcelona concert
1st July 1993

Cesar Diaz went from technician to band member back to technician.

But he was allowed to join the band on stage for a few songs on his birthday. (Juan les Pins 1992 and Cascais 1993)

Cesar Diaz
at the
Barcelona soundcheck

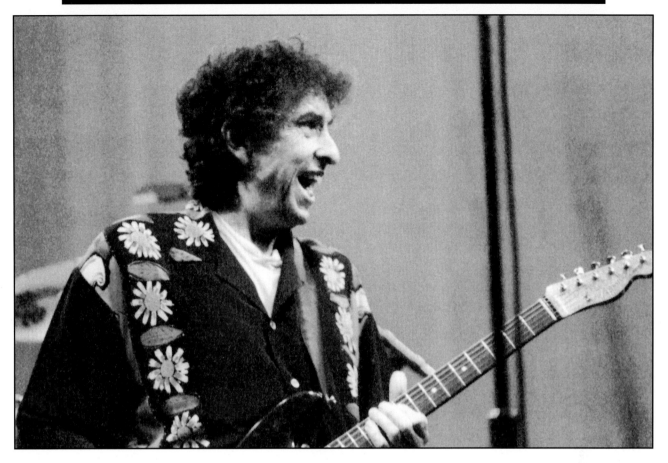

Cascais Portugal 13th July 1993

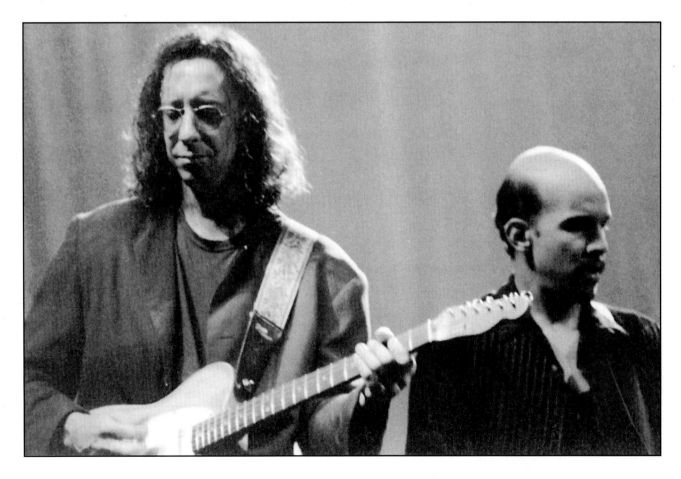

John Jackson and Cesar Diaz Cascais Portugal 13th July 1993
(Cesar's birthday appearance)

THE LAST SUPPER

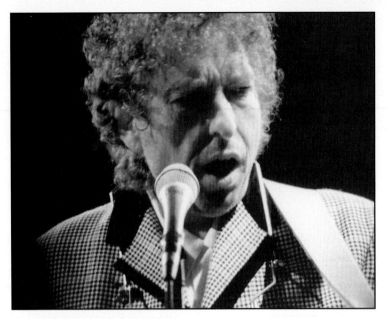

In Late 1993 I was in the middle of moving house from Northern Ireland to England, so I hadn't been keeping up to date with any news of Dylan's current activities.

I phoned a friend one Sunday evening to ask if I could call and see him the coming week as I'd be in his area for a few days.

He said I could call round but he would be in New York, and he proceeded to fill me in on the news of the Supper Club shows in two days' time ! There had been whispers and rumours the month before that Dylan was trying to set up some shows in a small club in New York, but as the rumours had died down and I'd been busy with the hassle of moving into a new house, I'd not given them much thought.

Now I know you can't see every performance that Dylan gives, (and even if you could, would you really want to ?) but I thought that this would be something really special and I didn't want to miss it.

There would be two shows each night for two nights, and it was going to be filmed for Dylan's contribution to the 'Unplugged' series on MTV. Dylan hadn't played two shows in one day since the Rolling Thunder Revue tour in the mid 70's when they played shows in the afternoon and evening. He also hadn't played an all acoustic show in a small club in New York since the sixties ! I had to be there !

The only slight problem with my plan was the tickets had already been given away at a record store in New York, and they had been limited to 2 per person for the people queueing up overnight. So with every fan needing 4 tickets just for themselves, I would have a tough time even getting into the club. There was also the small detail of needing to book a flight to New York the following morning when the travel agent opened.

I got the flight sorted out, and arrived in New York's J.F.K. Airport at about 5pm on the evening of the first show. The taxi ride into the city would normally take at least an hour, but this one took longer as my friend in England had given me the wrong address for the Supper Club and it wasn't listed in the only guide book the cab driver had.

I eventually arrived at the venue at around 6.30. The doors were due to open at 7 for the first show at 8pm.

So, I was standing outside the venue with my luggage, I had no tickets, and no place to stay after the show, and the doors were due to open in about 25 minutes - apart from that there was nothing to worry about .

After some frantic running around, pulling a few strings and calling in a few favours, I eventually got things sorted, and made it inside the club to see some of the finest performances Dylan has ever given. I had cut it fine to get there in time but it was worth all the effort. These were among the best Dylan shows I'd ever seen, if not *the* very best.

In the end, either Dylan or (more likely) MTV didn't approve of the finished film, and a year later they filmed a much more subdued performance, which was subsequently released as 'Unplugged'. The released version might have been more suitable for MTV's audience, but every Dylan fan around the world would have much preferred the original take at the Supper Club, when he was much more upbeat and animated, and gave a far superior performance, playing a more interesting selection of songs. We were robbed !

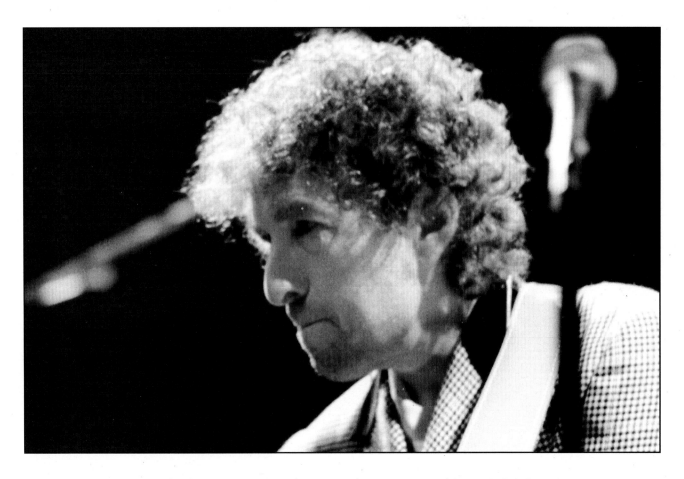

The Supper Club New York 17th November 1993 (10pm show)

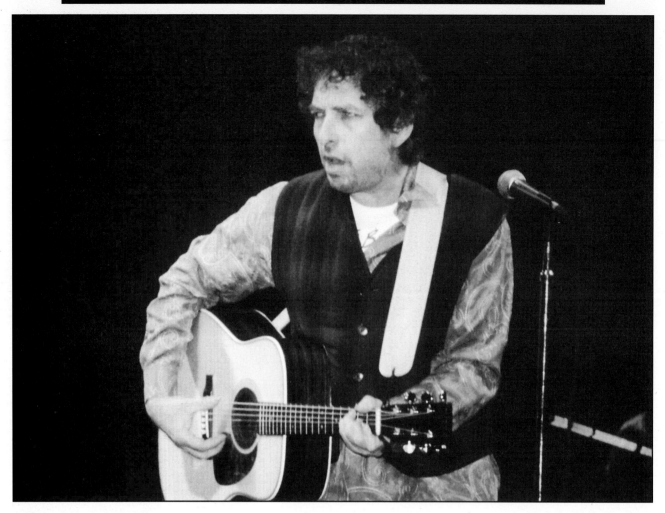

The Point Depot Dublin 5th Feb 1993

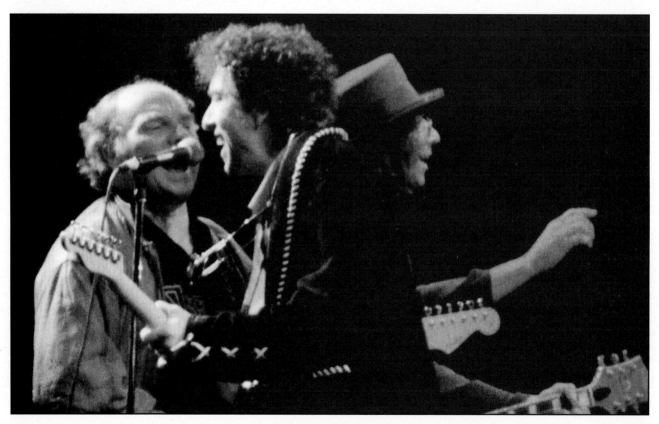

Finsbury Park 'Fleadh' London 12th June 1993
(with Van Morrison)

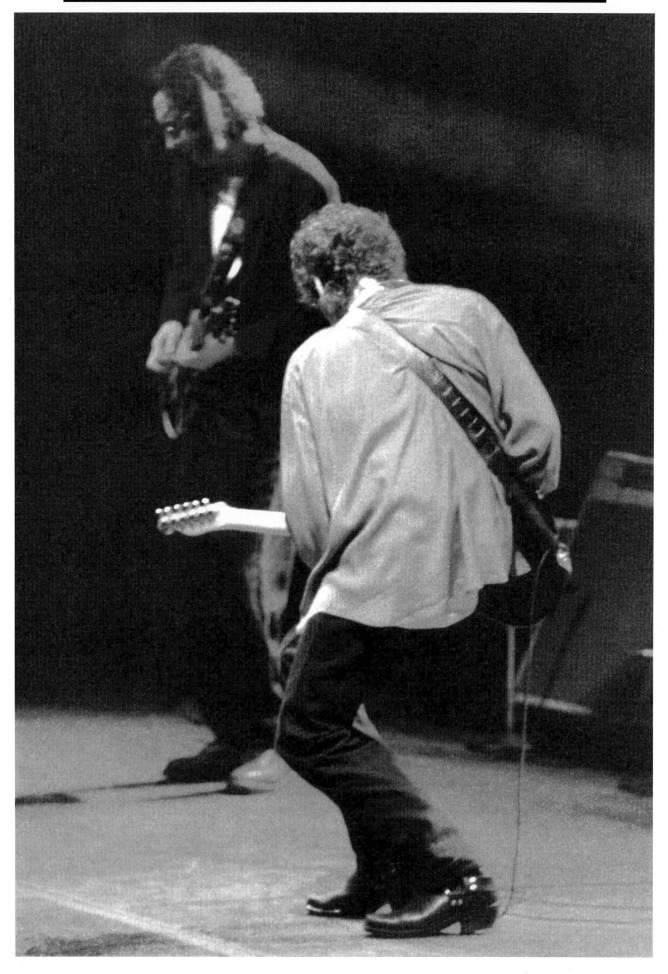

Utrecht Holland 16th Feb 1993

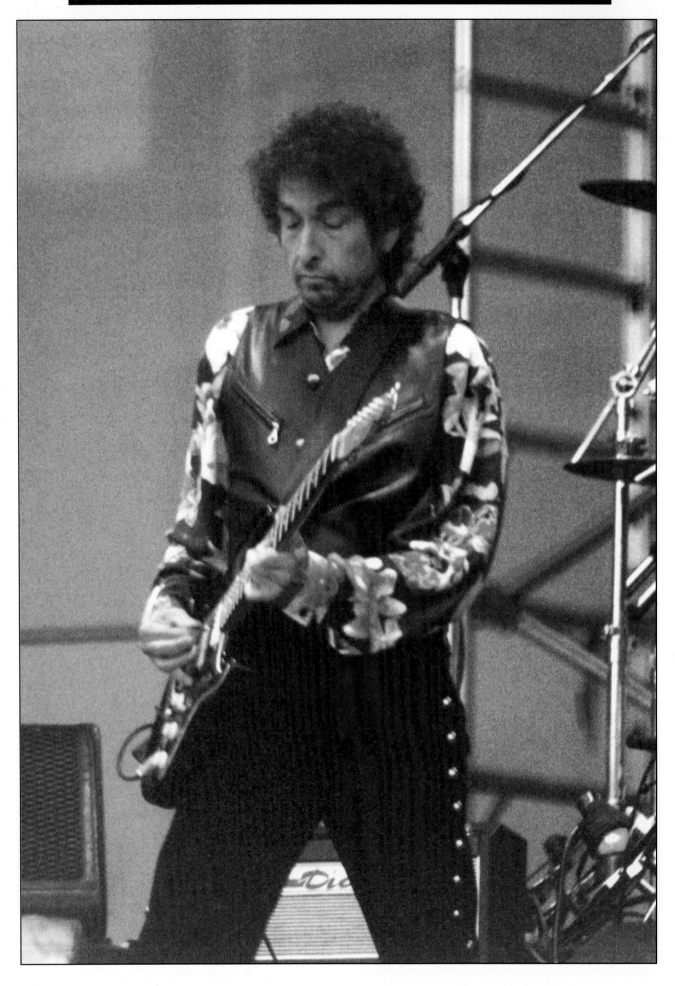

La Coruña Spain 9th July 1993

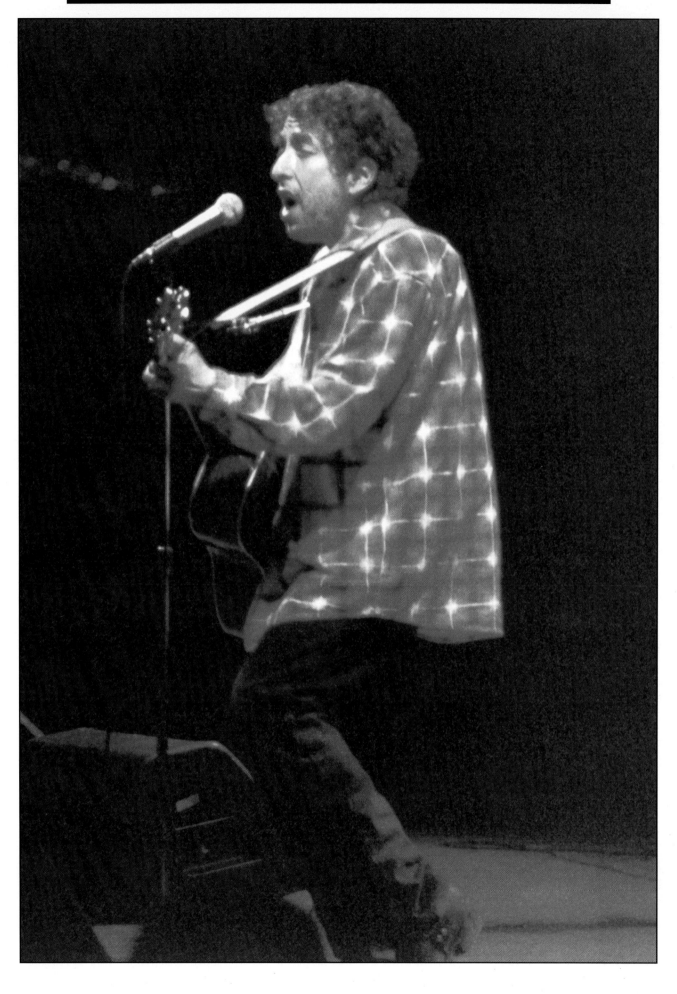

Utrecht Holland 15th Feb 1993

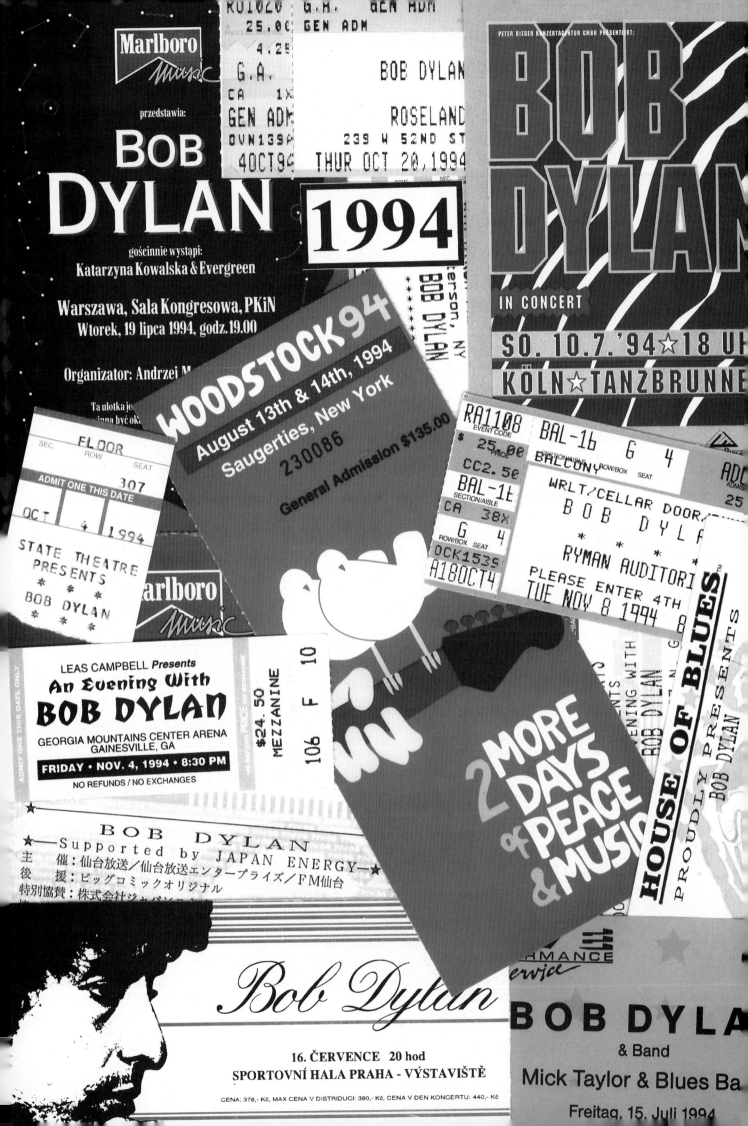

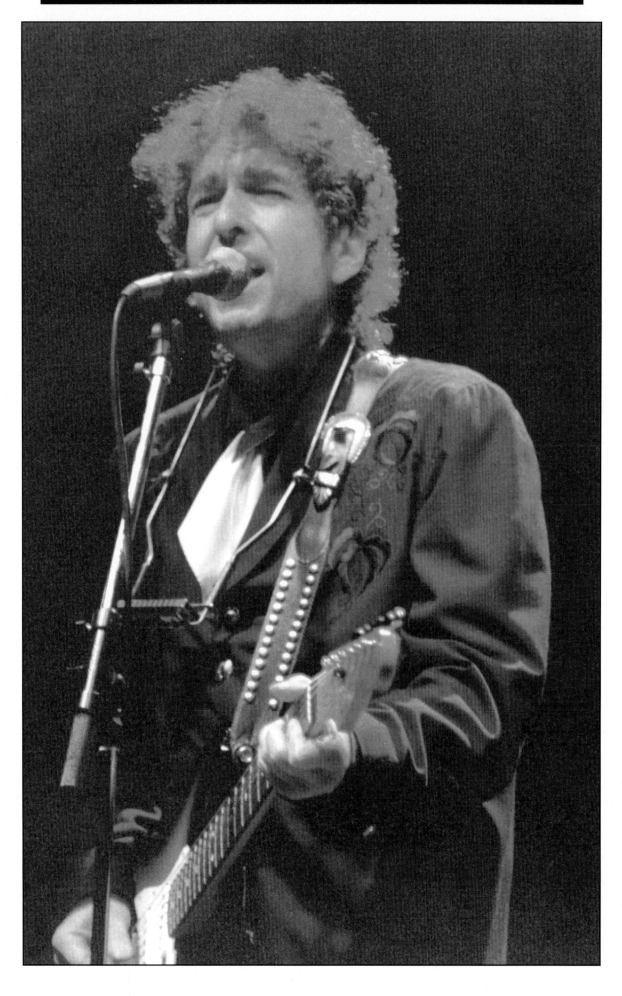

Roseland Ballroom New York 19th Oct 1994

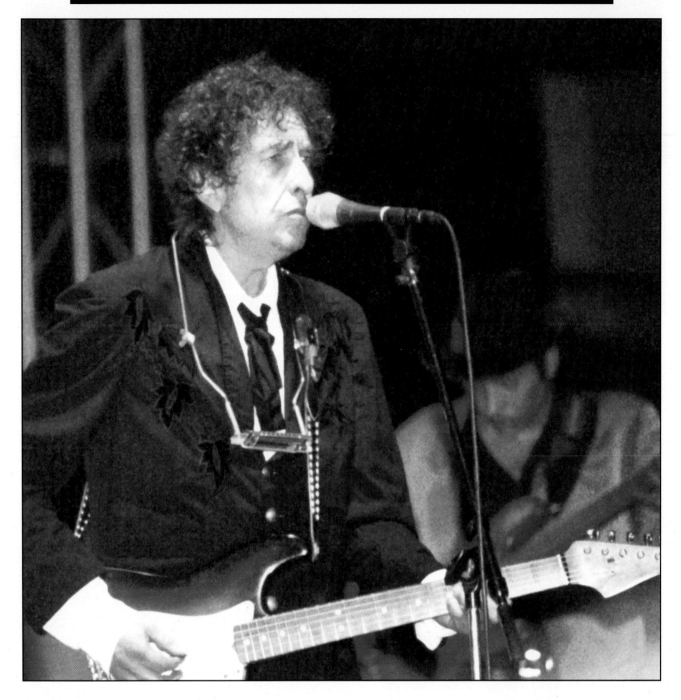

Prague 16th July 1994

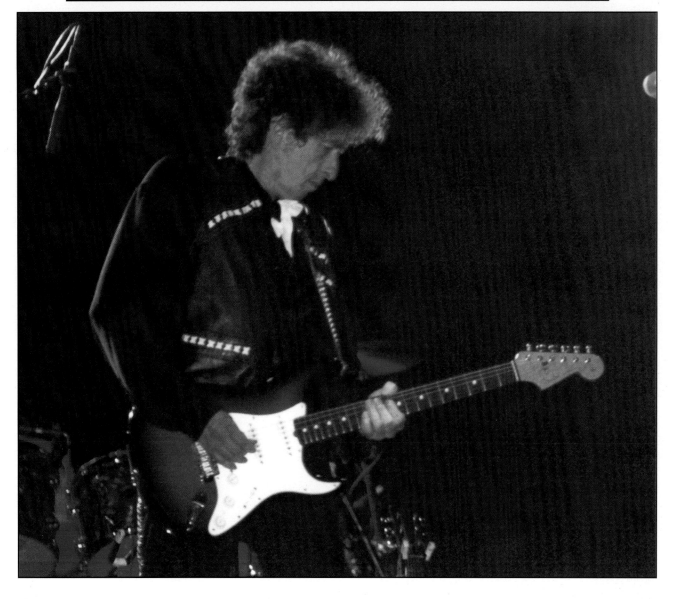

Krakow Poland 17th July 1994

Warsaw Poland 19th July 1994

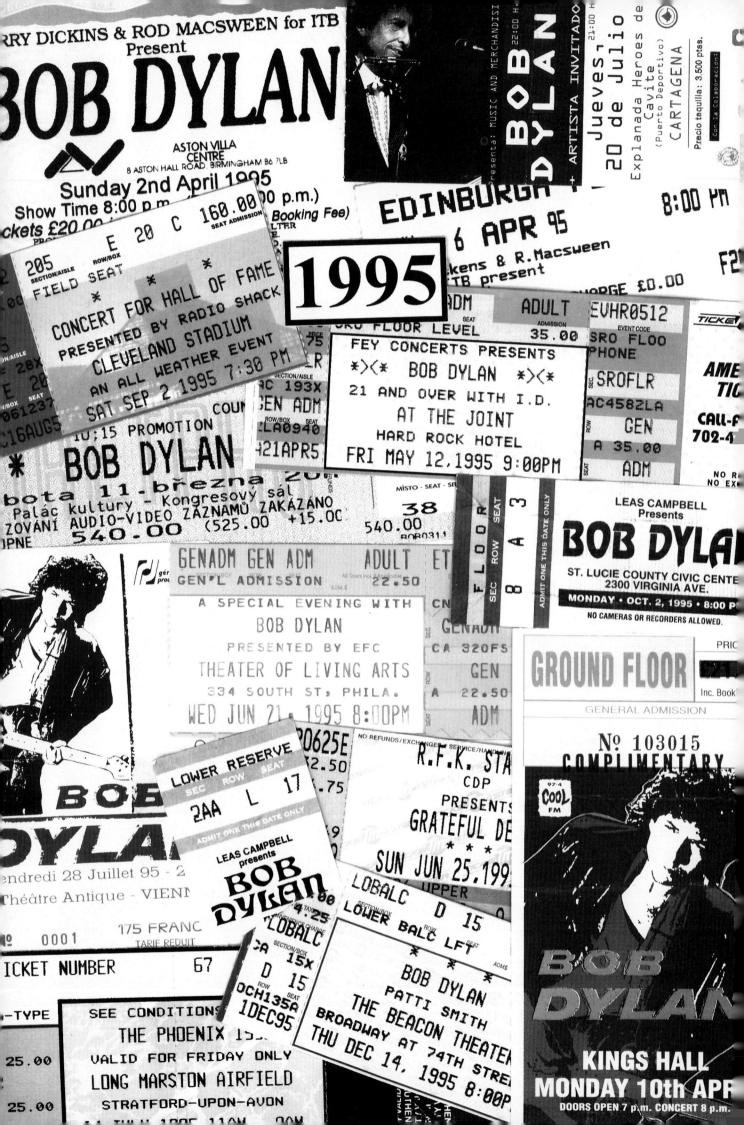

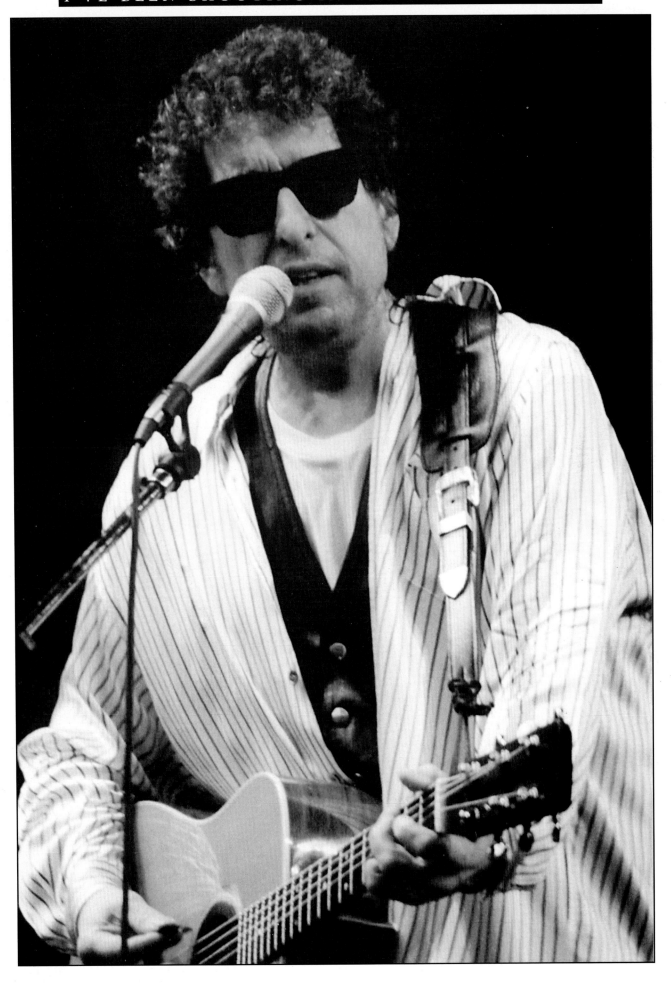

R.F.K Stadium Washington D.C. 24th June 1995

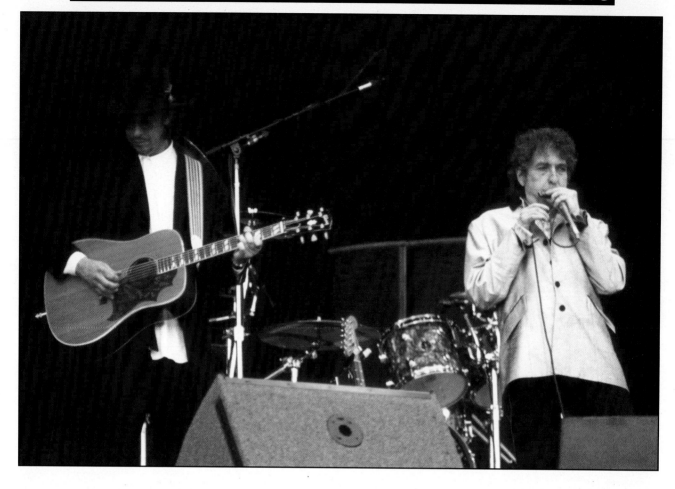

The Phoenix Festival Stratford - upon- Avon 14th July 1995

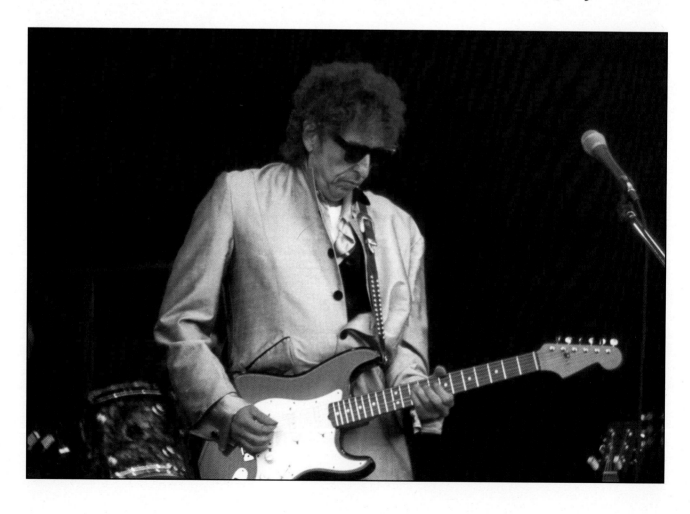

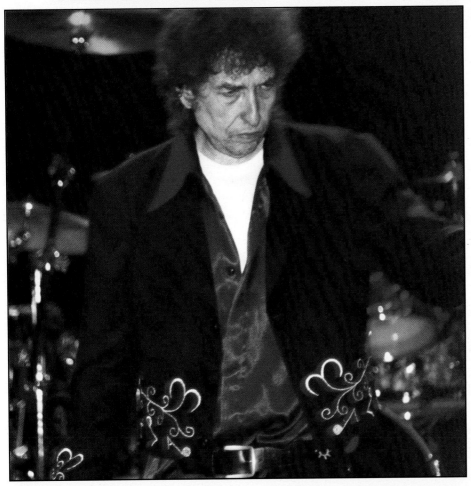

Brixton
Academy
London
30th March
1995

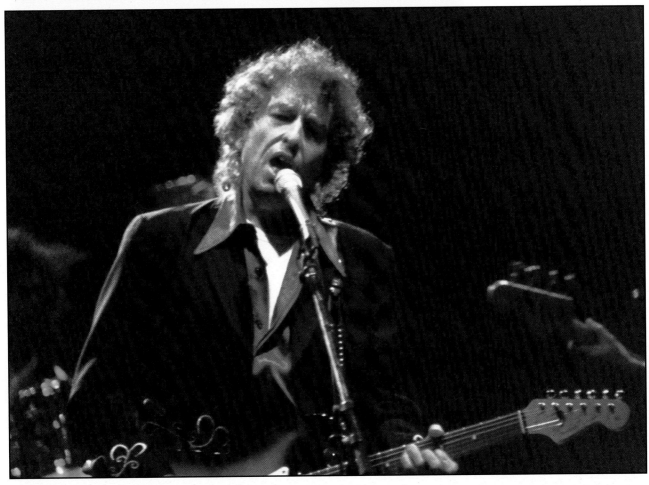

Apollo Theatre Manchester 5th April 1995

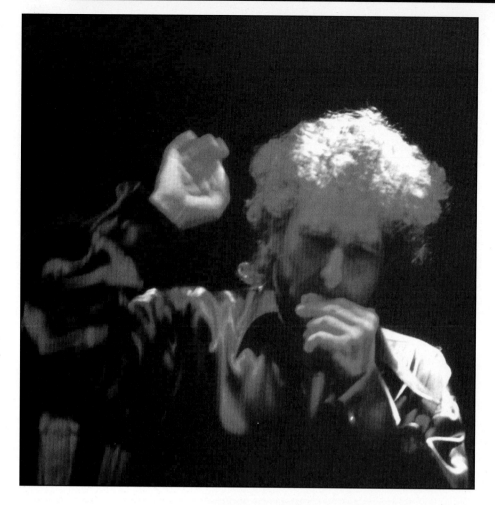

Kings Hall
Belfast
10th April
1995

Palace of
Culture
Prague
12th March
1995

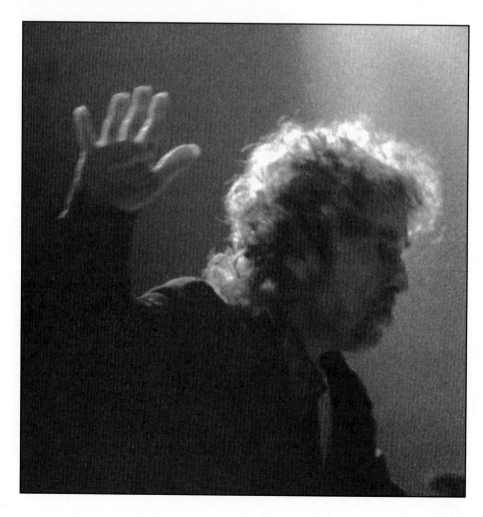

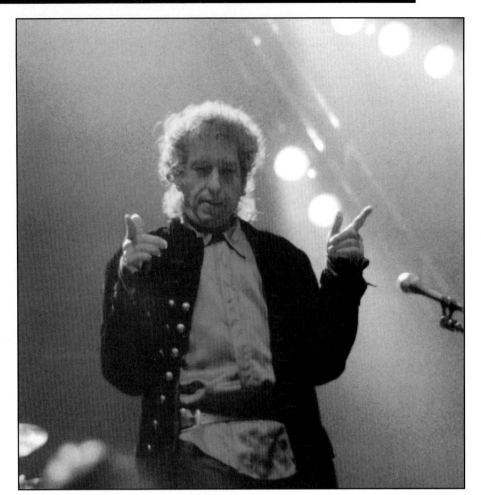

The Point Depot
Dublin
11th April
1995

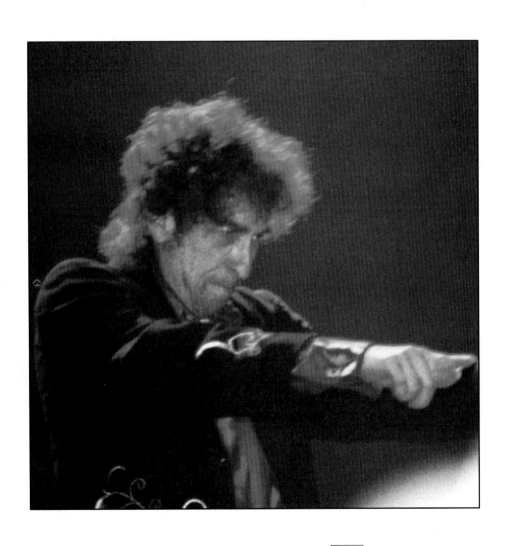

Kings Hall
Belfast
10th April
1995

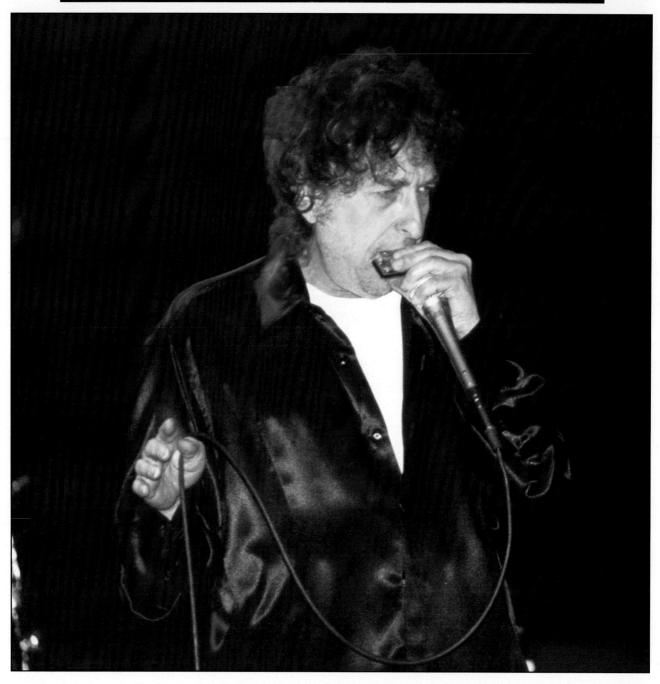

Brighton 26th March 1995

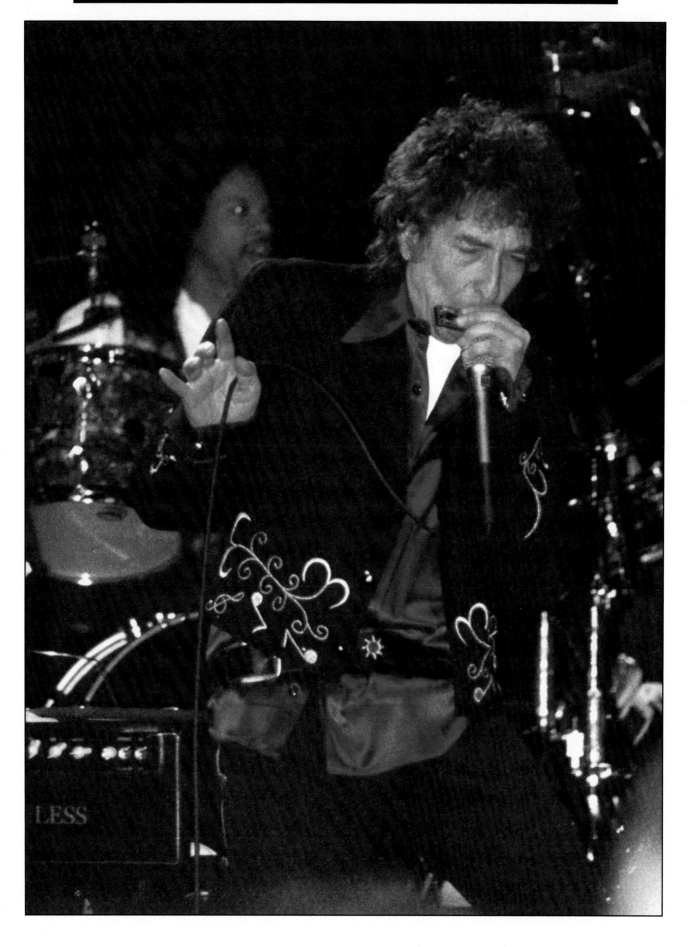

I'VE BEEN SHOOTING IN THE DARK TOO LONG

Brixton Academy London 30 March 1995

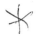

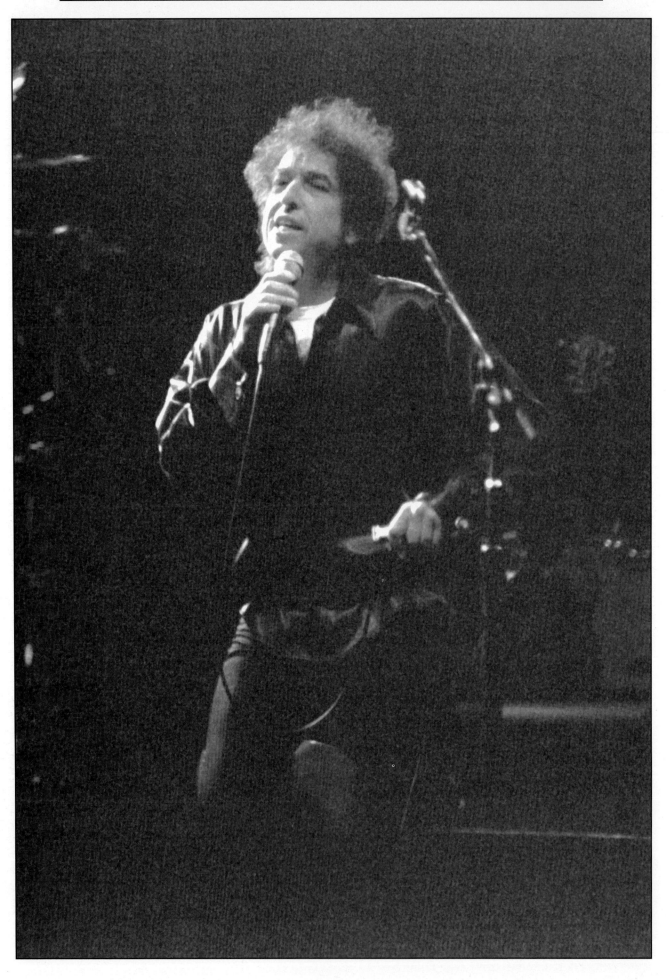

Cardiff 27th March 1995

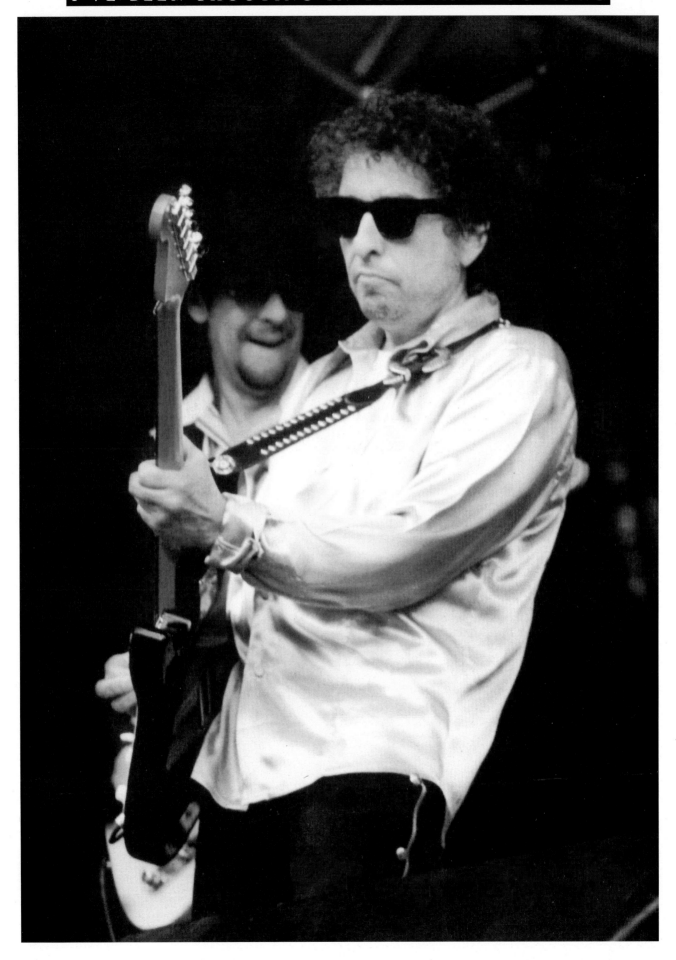

Washington D.C. 25th June 1995

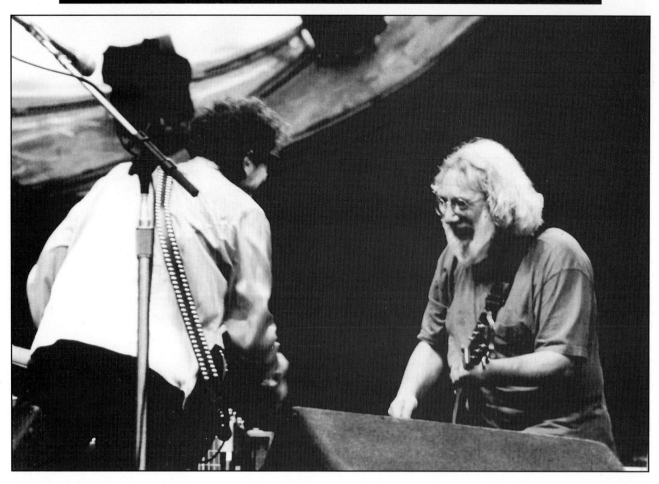

With Jerry Garcia Washington D.C. 25th June 1995

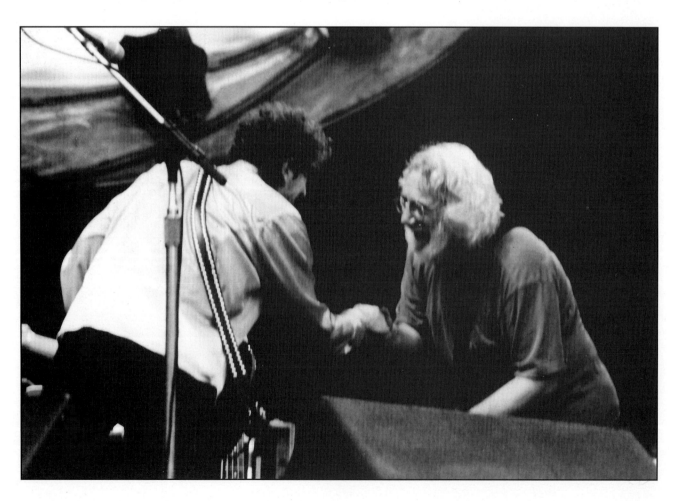

In June 1995, Dylan was supporting the Grateful Dead on 5 American shows, but they hadn't joined in each other's set until the very last show on 25th June, when Jerry Garcia came on stage for the last 2 songs of Dylan's set. He stayed on one side of the stage, some distance from Dylan, but Bob spent the whole time laughing and grinning towards him, obviously enjoying his presence.

At the end of 'It takes a lot to laugh...' Dylan went across and exchanged a few words with Garcia and they smiled and shook hands. After the final song, 'Rainy Day Women', Dylan again went across to Garcia's side of the stage, and patted him on the shoulder as he made his way off stage.

This would be the last time they appeared together on stage, and on August 9th Jerry Garcia was found dead in a clinic north of San Francisco.

This is part of Dylan's press statement issued the following day :

"There is no way to measure his greatness or magnitude as a person or as a player. To me he wasn't only a musician and friend, he was more like a big brother who taught and showed me more than he'll ever know. There's no way to convey the loss. It just digs down really deep".

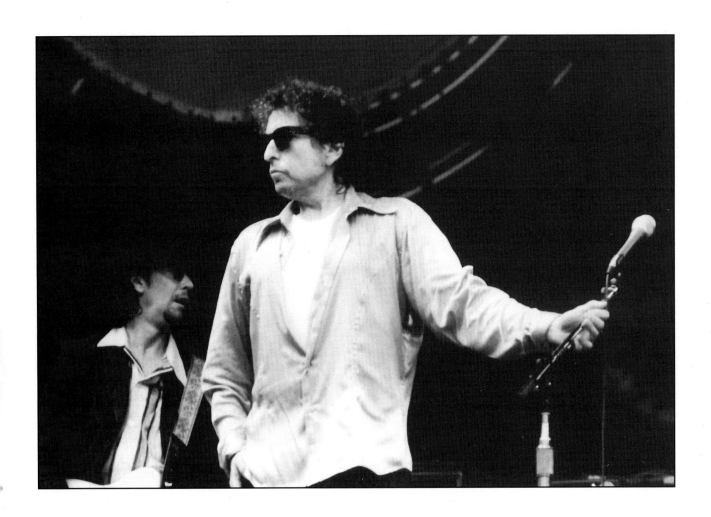

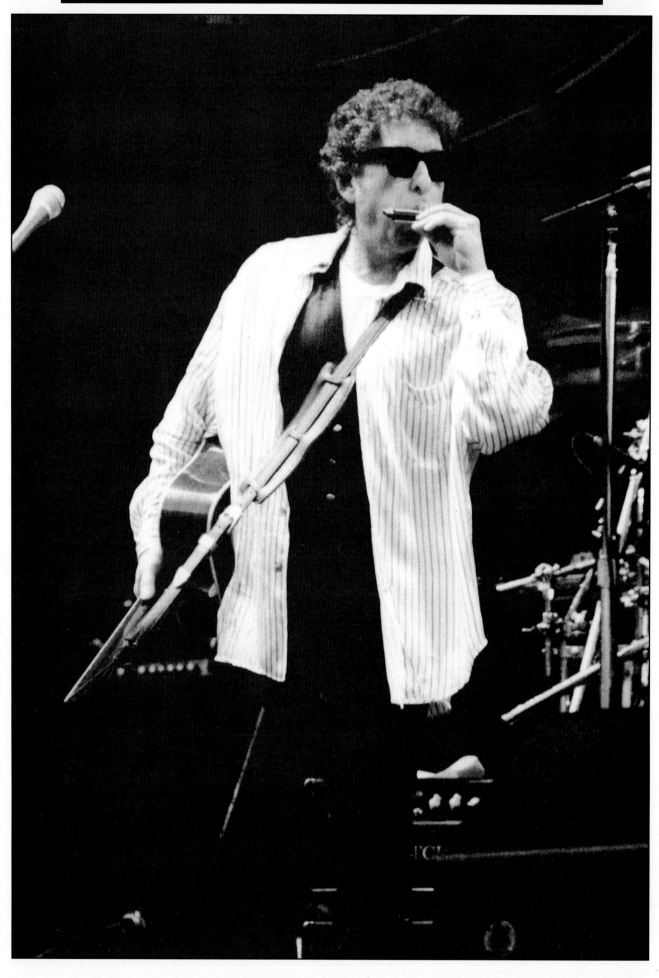

Washington D.C. 24th June 1995

The following pages show some of the occasions when Bob has been joined on stage by various guests and friends. (And doesn't his mood always seem to change, for the better, no matter who the guest is !)

Firstly, Van Morrison, one of the more regular visitors, (although they obviously never wasted time on rehearsing!). And then some photos from various years showing Santana, Ron Wood, Tom Petty, Al Kooper, Roger McGuinn, Dave Stewart, Elvis Costello, Carole King, Chrissie Hynde, and Jerry Garcia. There are also a couple of pictures of 'uninvited guests', when members of the audience suddenly decided to join him on stage.

Finally some *odds and ends*, capturing some personal encounters from along the way. Pictures of band members or some of the characters in the 'Dylan world' that I've bumped into in hotels before or after the concerts, or just walking around whatever town the tour happened to be passing through that particular day.

These unexpected encounters always add to the enjoyment of following a tour. Along with the planned meetings with friends and other fans from around the world, they have made the times spent before and after the concerts almost as enjoyable as the shows themselves.

For me, following Bob Dylan on tour has been a rich adventure. I have made many friends, visited many places, and seen some amazing shows - Thanks Bob!

With no end in sight to Dylan's continuous touring, I look forward to many more such good times. Bob has given us so much pleasure for so many years - long may he continue!

Prague 11th March 1995

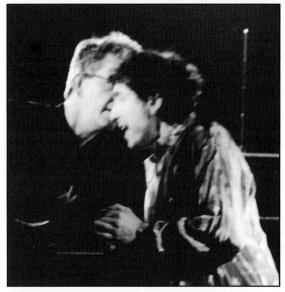

It's called E-n-l-i-g-h-t-e-n-m-e-n-t

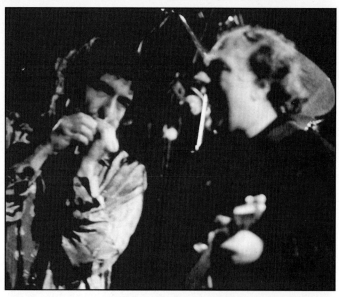

Milan 1991

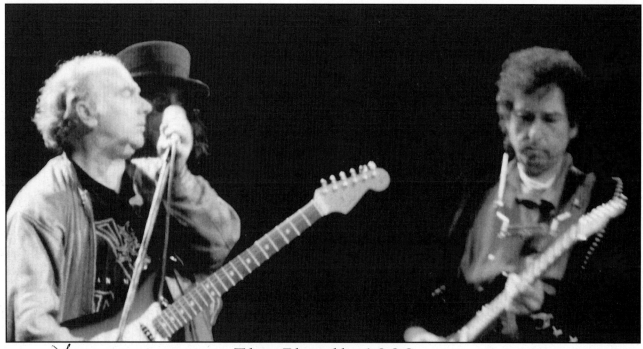

The Fleadh 1993

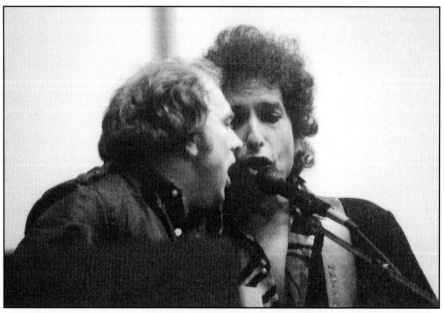

Slane 1984

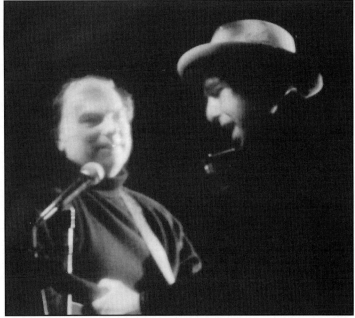

Belfast 1991

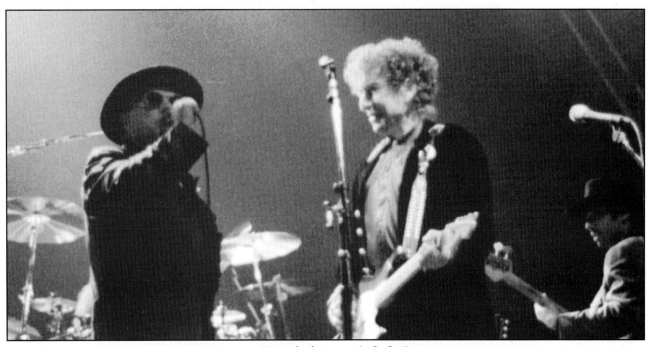

Dublin 1995

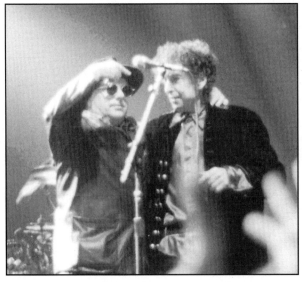

He's the man!

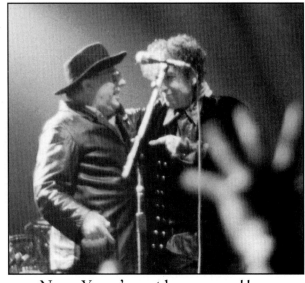

No, You're the man!!

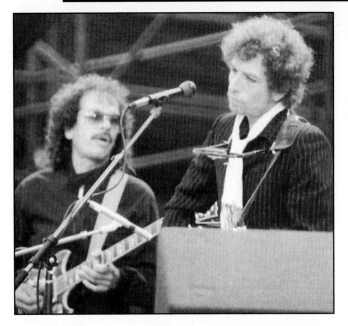

with Carlos Santana 1984

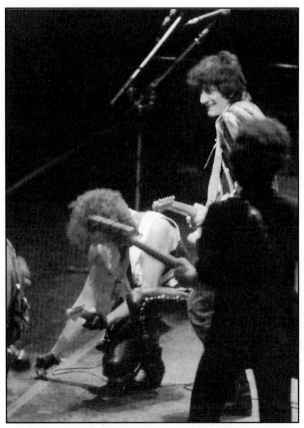

with Ron Wood 1986

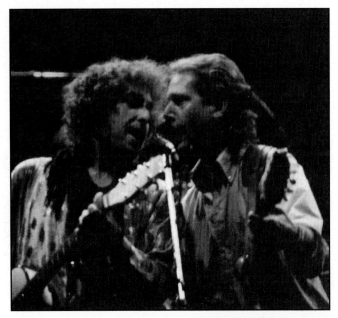

with Roger McGuinn 1987

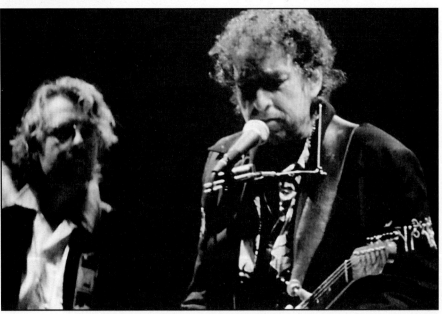

with Dave Stewart 1993

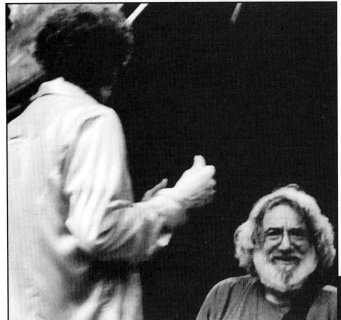

with Jerry Garcia 1995

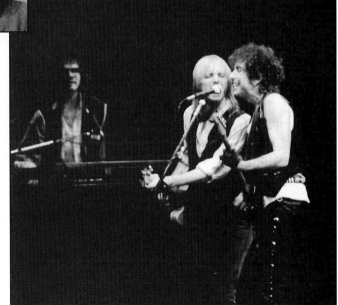

with Al Kooper & Tom Petty
1986

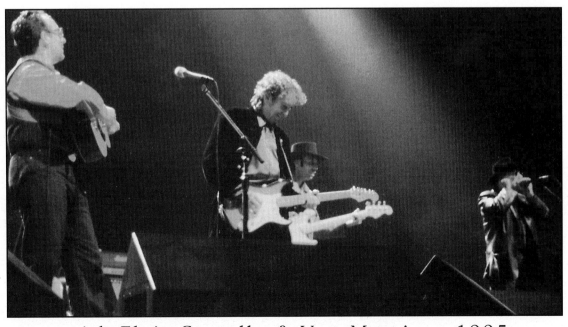

with Elvis Costello & Van Morrison 1995

with Elvis Costello 1995

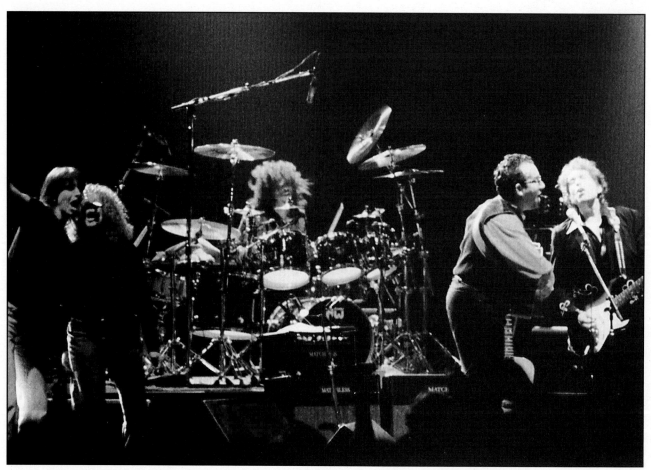

With Chrissie Hynde Carole King and Elvis Costello 1995

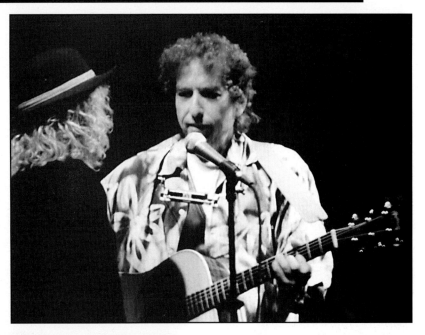

Bob offers his guitar to Liz Souissi, a member of the audience who joined him on stage in Eiendhoven 1993 for a wonderful duet on 'The Times They Are A Changin'.'

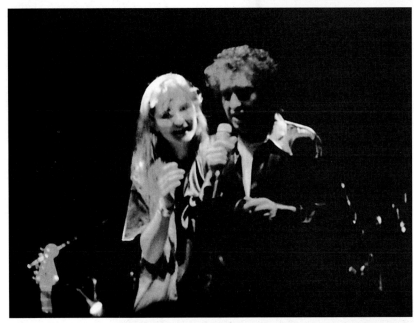

Another uninvited guest was Sigrid Maria Heindl who joined Bob on stage in Prague 1995.

"C'mon now Sir, you'll have to get off the stage."
"No, no, I'm supposed to be here - I'm Bob Dylan!"

'Grizzly' is the larger than life wrestler who made an appearance in the BBC documentary 'Getting to Dylan' when Bob was filming 'Hearts of Fire' in Hamilton, Ontario. Dylan called him over to join in the proceedings, and seemed genuinely pleased to see him. "I've been a fan of Bobby's for a long time". "Yeah, all wrestlers are!" replied Dylan.

Dylan then said to someone taking photos, "You gotta get me one with me and Grizzly too!"

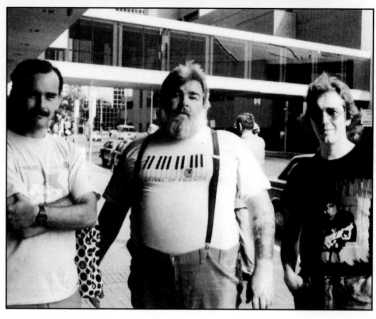

Bill Sommariva, 'Grizzly', and John Hume. Hamilton, Ontario.

Another 'character' was 'Sara' who was also mentioned in the same BBC documentary, allegedly telling Christopher Sykes that she was "Dylan's sister". Her name had appeared in another article six years earlier when Adrian Deevoy had interviewed Dylan for 'Q' magazine. A woman from Dylan's office in New York described her then as "an obsessed woman who follows Bob all over the world." 'Unbalanced', and 'extremely devious' were a few of the other labels they'd given this frail looking girl who was listed on their computer along with 500 other 'potentially dangerous' fanatics. I had spoken to her numerous times in Europe and America over a period of five years or more, and when we found her hitch-hiking from Yugoslavia to Hungary I was treated to over two hours of her stories, including some of her meetings and conversations with Dylan. We were en route to Budapest for what would be my 100th Dylan concert, and she'd already seen over 400, but the travelling had taken its toll and she sounded like she couldn't go on doing this for much longer. She said, "I may not get a *diamond as big as your shoe* but there has to be some end to this story."

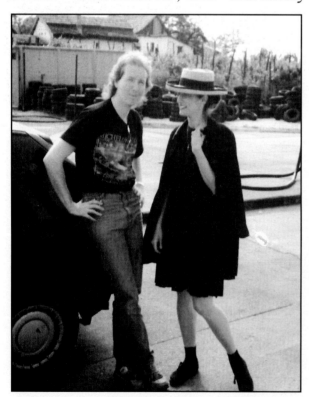

John Hume with Sara, somewhere in Hungary, 1991

John Jackson photographs one of
the opening acts at Leysin.
(Nice hat J.J. !)

Tony Garnier and Trish
South of France 1992

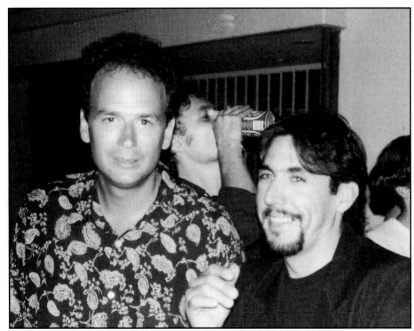

Bucky Baxter
and
Charlie Quintana

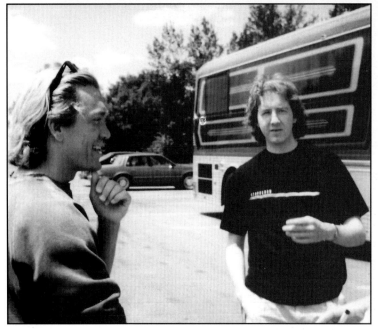

G.E.Smith & John Hume
Canadaigua 1988

Cesar Diaz
and Di Kamp
Belfast 1993

John Hume
Belfast 1993

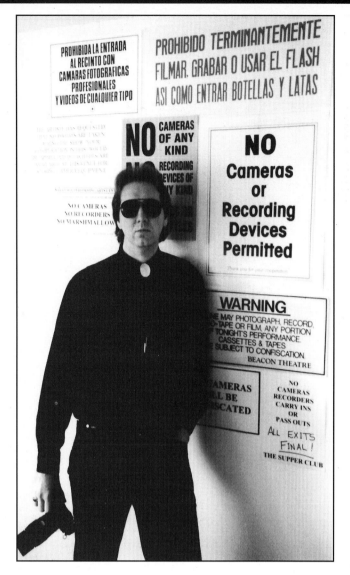

John Hume was born in Northern Ireland in 1959, and is currently living in England.

His photos have been used in several major books on Bob Dylan, including those by Paul Williams, John Bauldie , Michael Gray, Clinton Heylin, Patrick Humphries and Richard Williams. His photographs have also featured in many booklets and fanzines, as well as in newspapers and magazines in Italy, Holland, Northern Ireland, USA and the Czech Republic.

Although his main photographic interest is Bob Dylan, he has also photographed The Rolling Stones, The Grateful Dead, Bruce Springsteen, Joan Baez, Tom Petty, Sheryl Crow, Rickie Lee Jones, Tracy Chapman, Joan Armatrading, Laurie Anderson, Santana, David Bowie, Van Morrison and Eric Clapton.

An Exhibition of his Bob Dylan photos was displayed at the Edinburgh Festival in 1994, the biggest Arts Festival in the world.

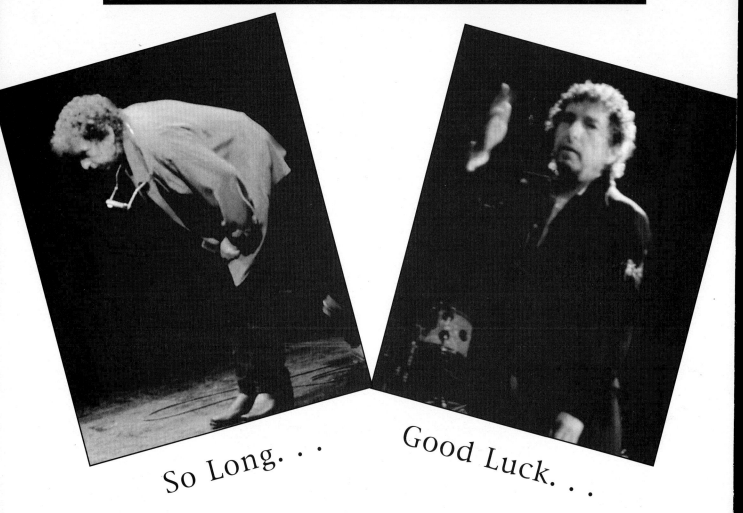

So Long. . . Good Luck. . .

and Goodbye !